LR 002.500 061012 £499

CW00342808

Francis Frith's
HUMBERSIDE

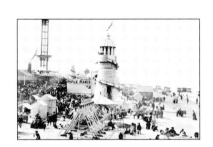

PHOTOGRAPHIC MEMORIES

Francis Frith's

HUMBERSIDE

◆

John A Milnes

FRITH
BOOK Co

First published in the United Kingdom in 2000 by
Frith Book Company Ltd

Hardback Edition 2000
ISBN 1-85937-215-5

Paperbackback Edition 2002
ISBN 1-85937-605-3

Reprinted in paperback 2002

British Library Cataloguing in Publication Data

Francis Frith's Humberside
John A Milnes

Frith Book Company Ltd
Frith's Barn, Teffont,
Salisbury, Wiltshire SP3 5QP
Tel: +44 (0) 1722 716 376
Email: info@francisfrith.co.uk
www.francisfrith.co.uk

Printed and bound in Great Britain

Contents

Francis Frith: *Victorian Pioneer*

FRANCIS FRITH, Victorian founder of the world-famous photographic archive, was a complex and multitudinous man. A devout Quaker and a highly successful Victorian businessman, he was both philosophic by nature and pioneering in outlook.

By 1855 Francis Frith had already established a wholesale grocery business in Liverpool, and sold it for the astonishing sum of £200,000, which is the equivalent today of over £15,000,000. Now a multi-millionaire, he was able to indulge his passion for travel. As a child he had pored over travel books written by early explorers, and his fancy and imagination had been stirred by family holidays to the sublime mountain regions of Wales and Scotland. 'What a land of spirit-stirring and enriching scenes and places!' he had written. He was to return to these scenes of grandeur in later years to 'recapture the thousands of vivid and tender memories', but with a different purpose. Now in his thirties, and captivated by the new science of photography, Frith set out on a series of pioneering journeys to the Nile regions that occupied him from 1856 until 1860.

Intrigue and Adventure

He took with him on his travels a specially-designed wicker carriage that acted as both dark-room and sleeping chamber. These far-flung journeys were packed with intrigue and adventure. In his life story, written when he was sixty-three, Frith tells of being held captive by bandits, and of fighting 'an awful midnight battle to the very point of surrender with a deadly pack of hungry, wild dogs'. Sporting flowing Arab costume, Frith arrived at Akaba by camel seventy years before Lawrence, where he encountered 'desert princes and rival sheikhs, blazing with jewel-hilted swords'.

During these extraordinary adventures he was assiduously exploring the desert regions bordering the Nile and patiently recording the antiquities and peoples with his camera. He was the first photographer to venture beyond the sixth cataract. Africa was still the mysterious 'Dark Continent', and Stanley and Livingstone's historic meeting was a decade into the future. The conditions for picture taking confound belief. He laboured for hours in his wicker dark-room in the sweltering heat of the desert, while the volatile chemicals fizzed dangerously in their trays. Often he was forced to work in remote tombs and caves where conditions were cooler. Back in London he exhibited his photographs and was 'rapturously

cheered' by members of the Royal Society. His reputation as a photographer was made overnight. An eminent modern historian has likened their impact on the population of the time to that on our own generation of the first photographs taken on the surface of the moon.

Venture of a Life-Time

Characteristically, Frith quickly spotted the opportunity to create a new business as a specialist publisher of photographs. He lived in an era of immense and sometimes violent change. For the poor in the early part of Victoria's reign work was a drudge and the hours long, and people had precious little free time to enjoy themselves. Most had no transport other than a cart or gig at their disposal, and had not travelled far beyond the boundaries of their own town or village.

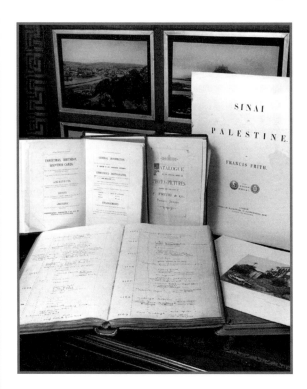

However, by the 1870s, the railways had threaded their way across the country, and Bank Holidays and half-day Saturdays had been made obligatory by Act of Parliament. All of a sudden the ordinary working man and his family were able to enjoy days out and see a little more of the world.

With characteristic business acumen, Francis Frith foresaw that these new tourists would enjoy having souvenirs to commemorate their days out. In 1860 he married Mary Ann Rosling and set out with the intention of photographing every city, town and village in Britain. For the next thirty years he travelled the country by train and by pony and trap, producing fine photographs of seaside resorts and beauty spots that were keenly bought by millions of Victorians. These prints were painstakingly pasted into family albums and pored over during the dark nights of winter, rekindling precious memories of summer excursions.

The Rise of Frith & Co

Frith's studio was soon supplying retail shops all over the country. To meet the demand he gathered about him a small team of photographers, and published the work of independent artist-photographers of the calibre of Roger Fenton and Francis Bedford. In order to gain some understanding of the scale of Frith's business one only has to look at the catalogue issued by Frith & Co in 1886: it runs to some 670 pages, listing not only many thousands of views of the British Isles but also many photographs of most European countries, and China, Japan, the USA and Canada – note the sample page shown above

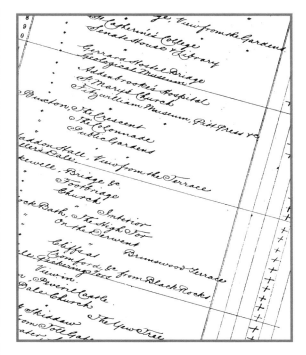

from the hand-written *Frith & Co* ledgers detailing pictures taken. By 1890 Frith had created the greatest specialist photographic publishing company in the world, with over 2,000 outlets – more than the combined number that Boots and WH Smith have today! The picture on the right shows the *Frith & Co* display board at Ingleton in the Yorkshire Dales. Beautifully constructed with mahogany frame and gilt inserts, it could display up to a dozen local scenes.

Postcard Bonanza

The ever-popular holiday postcard we know today took many years to develop. In 1870 the Post Office issued the first plain cards, with a pre-printed stamp on one face. In 1894 they allowed other publishers' cards to be sent through the mail with an attached adhesive halfpenny stamp. Demand grew rapidly, and in 1895 a new size of postcard was permitted called the court card, but there was little room for illustration. In 1899, a year after Frith's death, a new card measuring 5.5 x 3.5 inches became the standard format, but it was not until 1902 that the divided back came into being, with address and message on one face and a full-size illustration on the other. *Frith & Co* were in the vanguard of postcard development, and Frith's sons Eustace and Cyril continued their father's monumental task, expanding the number of views offered to the public and recording more and more places in Britain, as the coasts and countryside were opened up to mass travel.

Francis Frith died in 1898 at his villa in Cannes, his great project still growing. The archive he created continued in business for another seventy years. By 1970 it contained over a third of a million pictures of 7,000 cities, towns and villages. The massive photographic record Frith has left to us stands as a living monument to a special and very remarkable man.

Frith's Archive: *A Unique Legacy*

FRANCIS FRITH'S legacy to us today is of immense significance and value, for the magnificent archive of evocative photographs he created provides a unique record of change in 7,000 cities, towns and villages throughout Britain over a century and more. Frith and his fellow studio photographers revisited locations many times down the years to update their views, compiling for us an enthralling and colourful pageant of British life and character.

We tend to think of Frith's sepia views of Britain as nostalgic, for most of us use them to conjure up memories of places in our own lives with which we have family associations. It often makes us forget that to Francis Frith they were records of daily life as it was actually being lived in the cities, towns and villages of his day. The Victorian age was one of great and often bewildering change for ordinary people, and

though the pictures evoke an impression of slower times, life was as busy and hectic as it is today.

We are fortunate that Frith was a photographer of the people, dedicated to recording the minutiae of everyday life. For it is this sheer wealth of visual data, the painstaking chronicle of changes in dress, transport, street layouts, buildings, housing, engineering and landscape that captivates us so much today. His remarkable images offer us a powerful link with the past and with the lives of our ancestors.

Today's Technology

Computers have now made it possible for Frith's many thousands of images to be accessed almost instantly. In the Frith archive today, each photograph is carefully 'digitised' then stored on a CD Rom. Frith archivists can locate a single photograph amongst thousands within seconds. Views can be catalogued and sorted under a variety of categories of place and content to the immediate benefit of researchers.

Inexpensive reference prints can be created for them at the touch of a mouse button, and a wide range of books and other printed materials assembled and published for a wider, more general readership - in the next twelve months over a hundred Frith local history titles will be published! The day-to-day workings of the archive are very different from how they were in Francis Frith's time: imagine the herculean task of sorting through eleven tons of glass negatives as Frith had to do to locate a

See Frith at www.francisfrith.co.uk

particular sequence of pictures! Yet the archive still prides itself on maintaining the same high standards of excellence laid down by Francis Frith, including the painstaking cataloguing and indexing of every view.

It is curious to reflect on how the internet now allows researchers in America and elsewhere greater instant access to the archive than Frith himself ever enjoyed. Many thousands of individual views can be called up on screen within seconds on one of the Frith internet sites, enabling people living continents away to revisit the streets of their ancestral home town, or view places in Britain where they have enjoyed holidays. Many overseas researchers welcome the chance to view special theme selections, such as transport, sports, costume and ancient monuments.

We are certain that Francis Frith would have heartily approved of these modern developments in imaging techniques, for he himself was always working at the very limits of Victorian photographic technology.

The Value of the Archive Today

Because of the benefits brought by the computer, Frith's images are increasingly studied by social historians, by researchers into genealogy and ancestry, by architects, town planners, and by teachers and schoolchildren involved in local history projects.

In addition, the archive offers every one of us an opportunity to examine the places where we and our families have lived and worked down the years. Highly successful in Frith's own era, the archive is now, a century and more on, entering a new phase of popularity.

The Past in Tune with the Future

Historians consider the Francis Frith Collection to be of prime national importance. It is the only archive of its kind remaining in private ownership and has been valued at a million pounds. However, this figure is now rapidly increasing as digital technology enables more and more people around the world to enjoy its benefits.

Francis Frith's archive is now housed in an historic timber barn in the beautiful village of Teffont in Wiltshire. Its founder would not recognize the archive office as it is today. In place of the many thousands of dusty boxes containing glass plate negatives and an all-pervading odour of photographic chemicals, there are now ranks of computer screens. He would be amazed to watch his images travelling round the world at unimaginable speeds through network and internet lines.

The archive's future is both bright and exciting. Francis Frith, with his unshakeable belief in making photographs available to the greatest number of people, would undoubtedly approve of what is being done today with his lifetime's work. His photographs, depicting our shared past, are now bringing pleasure and enlightenment to millions around the world a century and more after his death.

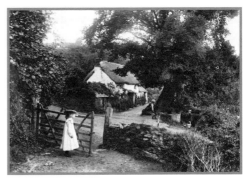

HUMBERSIDE - *An Introduction*

'I look upon all the world as my parish'.

THE ABOVE ADAGE comes from one of Hull's famous sons, John Wesley, the fiery founder of Methodism. It is still appropriate today for the Humberside area, although it was originally said during Wesley's lifetime in the 18th century. For if Wesley considered the world as his parish, he would be perplexed to know that Humberside only existed for 21 years - from 1974 until 1995.

Humberside as a county of north-east England was created by bureaucrats in 1974 out of North Lincolnshire and parts of the East and West Ridings of Yorkshire. Naturally, no thought was given to the cultural differences of those living south or north of the river. The same Act of Parliament also gave us Tyne and Wear, Teeside and Cleveland, and Lancashire was split apart by the grey-suited ones - Rochdale and Oldham became parts of Greater Manchester, and Blackpool was now the Fylde.

The indigenous folk of the East Riding fought long and hard for their identity, and never surrendered to this ill-judged legislation. Eventually the abolition of Humberside was announced in March 1995; Humberside was divided into the four unitary authorities of the East Riding of Yorkshire, Kingston upon Hull City, North Lincolnshire and North-East Lincolnshire.

So, although it is not a county in the true sense, as far as the photographs of Francis Frith are concerned, it is a unique region of Northern England divided now only by the mighty River Humber.

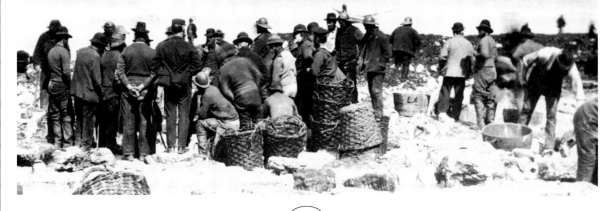

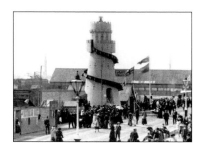

South of The Humber
North-East Lincolnshire

THIS REGION IS by far the smallest and the least populated of the five which make up the generic area of Humberside. But this was not always the case. In the Domesday Book of 1086 it was one of the most densely peopled parts of Britain; only the Black Death of 1349 led to a steady decline. There are at least 235 deserted medieval villages; many appear as merely bumps and hollows in the fields, but sometimes a church still stands.

By AD 886 the region had become part of the Danelaw. This is an 11th-century name for the parts of England settled by the Vikings in the 9th century. Within its bounds Danish law, customs and language prevailed, and its linguistic presence is still apparent. The 'by' and 'thorpe' endings of village names betray their Danish origins. The Romans had been here earlier, and were the first to use scientific attempts to reclaim the fertile but easily-flooded lands of the Fens. They dug canals, threw up embankments and made firm causeways. The monks followed, and gradually much of the Fenland was under cultivation. Finally, 350 years ago Vermuyden and his Dutch engineers re-drained the land using the experience gained in their native Holland.

Today, the only centre of any size and trade is Grimsby; it still has a substantial fishing fleet, although even this is much diminished since the Icelandic waters were closed to British fishing fleets. With the 'by' indicating Grimsby's Danish connections, there is a lovely local folk tale, for which I make no apology for quoting in full. But I leave you to decide the truth!

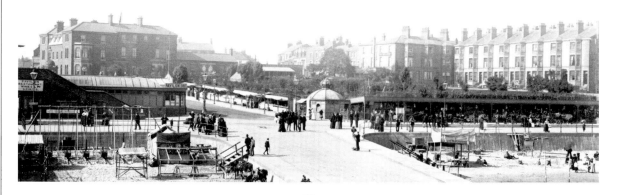

The Legend of Grim

King Athelwold of England dies, leaving his baby daughter, Goldborough. The appointed King, Godrich, Earl of Cornwall, takes care of Goldborough, and promises to fulfil the dead King's wish - to marry Goldborough to the strongest man in England when she is of age.

Meanwhile, King Birkabeyn of Denmark dies, and Earl Godard is given the job of caring for the baby Havelock and his two sisters. But Godard, wishing to rule, kills the King's daughters and instructs a local warrior and fisherman, Grim, to drown Havelock at sea. Grim tries to follow the Earl's instructions, but he cannot face killing the baby; he takes him from the water and goes home. Grim and his wife decide to bring the baby up as one of their own.

That night they see a ray of light shining out of the baby's mouth as he sleeps, and they discover a royal birthmark on his shoulder. Realising the baby's royal heritage and the danger they may be in, Grim and his family pack their belongings and set sail for England. When they land on British soil they found the town of Grimsby. Havelock grows up and goes to work in Lincoln. While there, he wins a shot-put competition. (The stone he threw still lies within the walls of Lincoln Castle). Havelock gains the reputation of being the strongest man in England.

Godrich, Earl of Cornwall hears of Havelock, and introduces Goldborough to him to keep the dead King's wish. Goldborough and Havelock marry in Lincoln and return home to Grimsby. That night, Goldborough dreams about Havelock becoming King and sees the light shining from his mouth in slumber. The next day Grim confirms

Havelock's birthright and Havelock returns to Denmark to claim his throne. Havelock returns in victory, and he and Goldborough become King and Queen of Denmark and England. They have fifteen children and reign happily together for 60 years.

A copy of the 13th-century text of 'The Lay of Havelock the Dane', a 3001-line rhyming poem telling the legend, can be found in Grimsby public library.

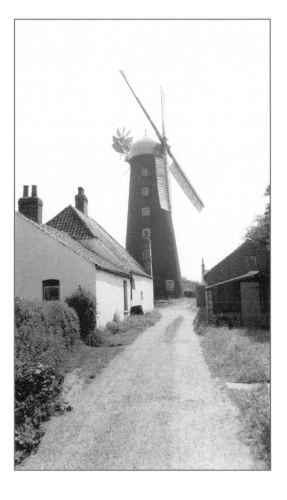

WALTHAM, THE MILL c1960 W319017
One of a multitude of mills in this area, this one took advantage of the on-shore winds coming from the North Sea. Since this picture was taken, it has been fully restored with its original six sails, and incorporates a museum and craft work shops.

Bracing Skegness

Whenever you hear of Skegness, the chances are that you remember the British Railways posters that decorated every station - you were invariably invited to 'Come to bracing Skegness'. And 'bracing' was the definitive adjective. Just a little way up the coast from Skegness lies Cleethorpes, with a similar climate. It does not have seasons like summer and winter - it is simply windy all year round. But it does have a fascinating history.

Clee originally consisted of three ancient areas - Itterby, Thrunscoe and Oole. The probable origins of the name are either from the Celtic word 'cleis', meaning chalk, or the old English word 'cleogh', meaning clay. The Danes added the 'thorpe', and Cleethorpes was born. The sea front soil based on clay eroded quickly, which is still a major problem for the East Coast throughout this entire area. In some parts the land slippage due to coastal erosion is measured in feet rather than inches a year. Hence property here is cheap; but don't try to get a long-term mortgage.

Neolithic and Bronze Age finds have been excavated in and around Cleethorpes, showing that the place has been continuously inhabited since ancient times. The town - formerly a village - remained small until recent years, with a population of 284 in 1801. But by the late 1820s the town had started to encourage its visitors, who came to enjoy the bracing climate, to bathe and to drink the medicinal iron-rich waters at Isaac's Hill. With the coming of the railway in 1840 the resort started to flourish; it changed from a genteel retreat for the upper-middle classes to catering for the thousands of working class holiday-makers, who came each year mainly from the industrialised South Yorkshire.

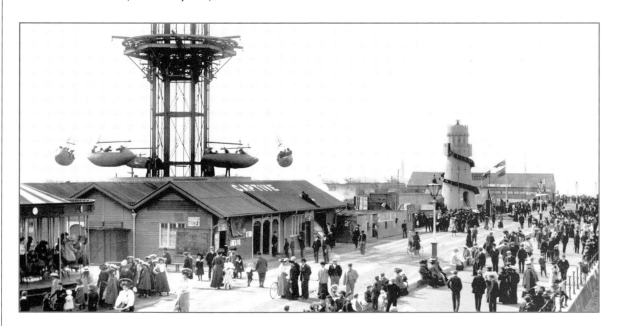

CLEETHORPES, THE FLYING MACHINE 1906 55735
Otherwise known as 'Wonderland', the pleasure beach and the Flying Machine dominating the sky-line were rivalled only by Blackpool. For safety reasons the structure was removed during the Second World War; it is sad that it was never replaced

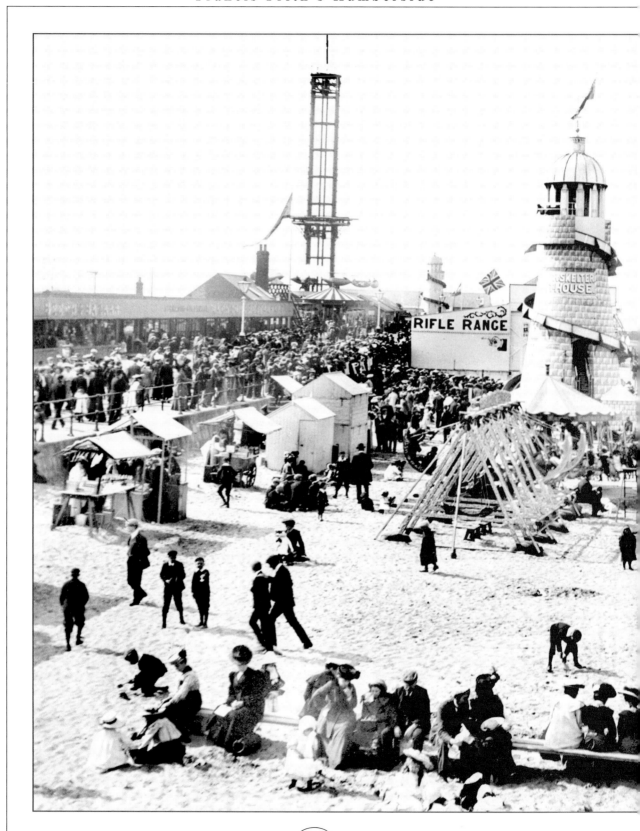

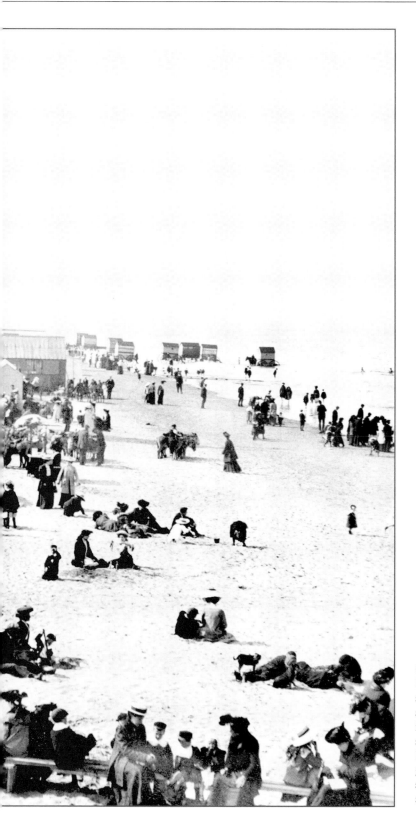

CLEETHORPES, THE BEACH 1906 55736
Here we have a wonderfully evocative sign of the times: a beach scene in high summer and not a glimpse of bare flesh. Cleethorpes liked its helter-skelters, as it had another on the beach. It survived two World Wars, but not the great floods of 1953. The entire seashore amusements were washed away in one night.

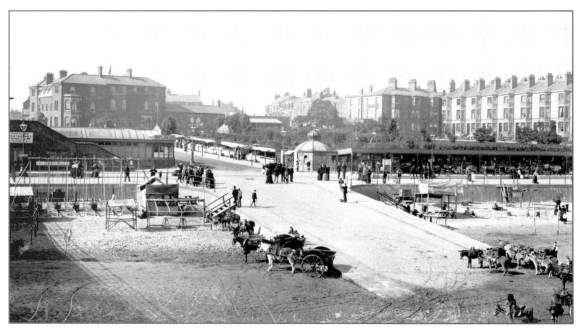

CLEETHORPES, THE VIEW FROM THE PIER 1899 44751
The grand Victorian hotel catering for the wealthy dominates the sky-line to the top left, mirrored by the terrace of cheaper B and Bs on the right. This was a period of class division, where only the beach was a shared common denominator.

CLEETHORPES, THE PROMENADE 1899 44750
This promenade area has changed out of all recognition; to all intents and purposes it is no longer there. The landscaped part on the left leading down to the sea was obliterated in the floods of 1953.

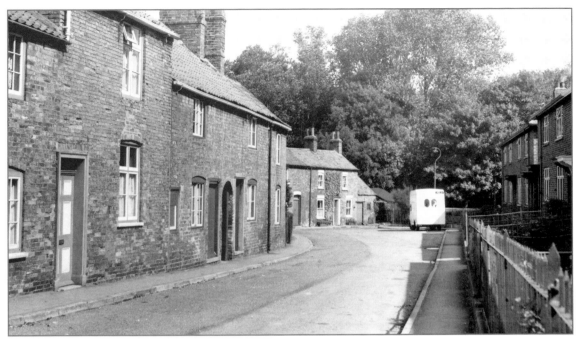

LACEBY, CHURCH LANE c1960 L228002
It is mid-afternoon siesta-time in the tranquillity of Laceby, a hamlet close to Grimsby. Only the white van indicates some form of human presence.

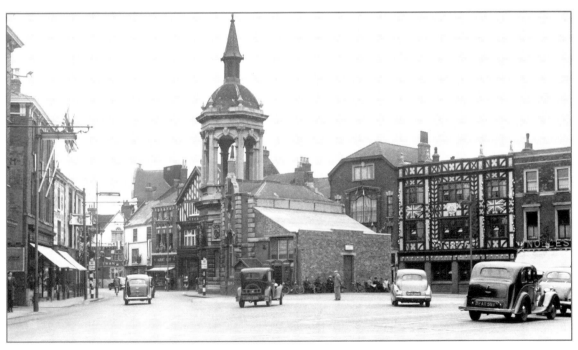

GRIMSBY, THE MARKET PLACE c1955 G60015
The market place, once a busy scene of local commerce, had already become a car park by this time. The ornate Victorian corn exchange survived demolition, and is now a theme pub called, rather obviously, The Exchange.

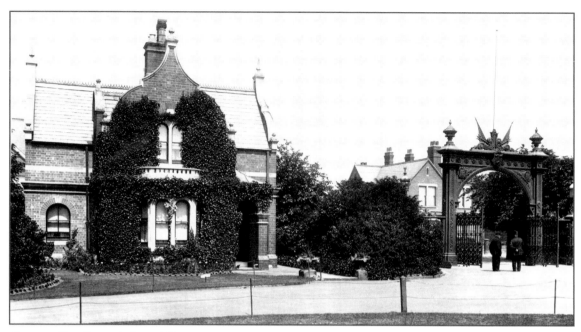

GRIMSBY, THE PEOPLE'S PARK 1904 51832

Actually the Park Keeper's house dominates the picture: it is a splendidly-spired residence when compared with the rather ordinary dwelling in the background. The typical wrought-iron gates, like so many others, met their fate in 1940 when they were smelted down for the war effort.

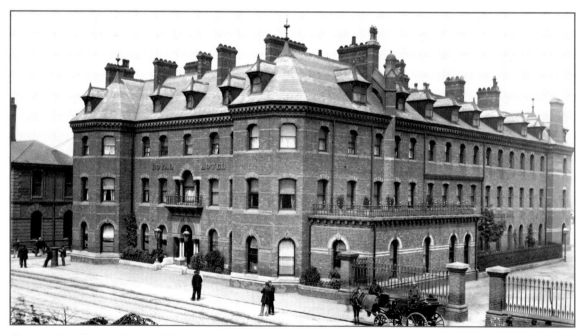

GRIMSBY, THE ROYAL HOTEL 1890 26724

The old Royal was demolished in the 1960s; it thrives today as a much smaller hotel called the Humber Royal, part of the Forte hotel chain. It is pleasing to see, for once, that a facility has not been lost but renewed to meet modern needs. For lovers of trivia, previous managers of the Royal were the parents of the actress Patricia Hodge.

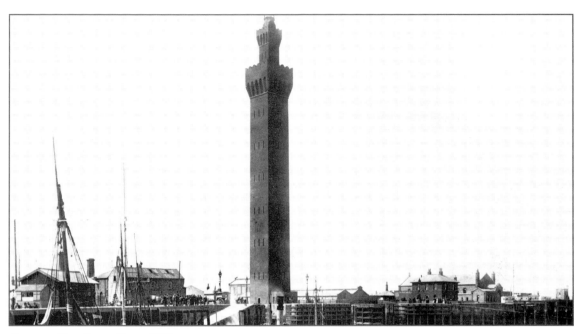

GRIMSBY, THE ROYAL DOCK 1890 26722
The Dock Tower dominating the photograph was a unique and strange piece of engineering. It was built in 1854 as an hydraulic accumulator to control the water pressure to enable the dock gates to be opened and closed; it also supplied power to the fifteen working cranes.

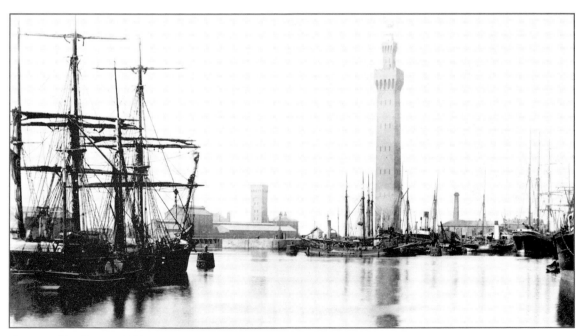

GRIMSBY, THE DOCKS 1893 33271
Queen Victoria and Prince Albert opened the Dock Tower in 1855, and Albert rode by lift the 309 feet to the top. It was designed after the style of the Palazzo Publico in Sienna, Italy. Electricity has taken over its original functions, but the Tower still stands proudly high above the docks.

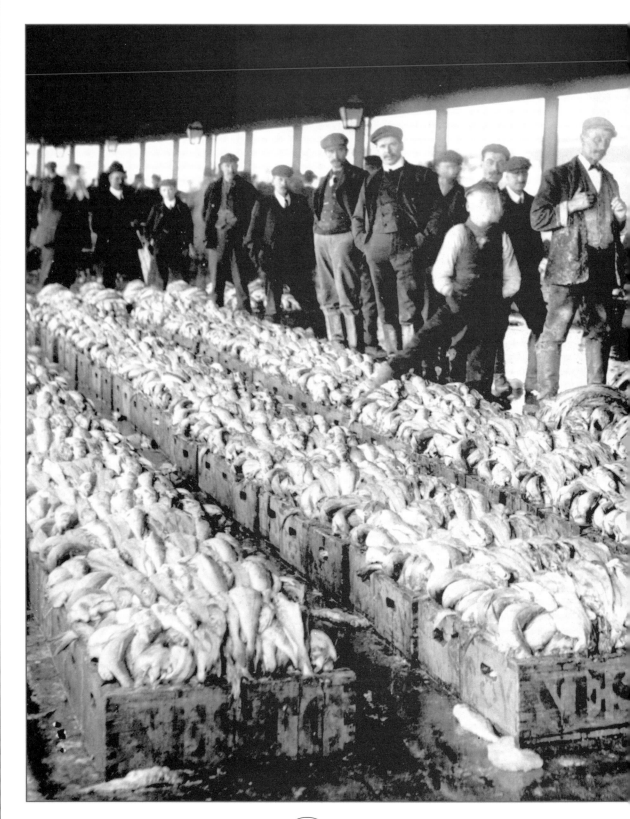

GRIMSBY

THE FISH PONTOON 1906 55750
In its day, Grimsby was the biggest fishing port in the world. Here, the local fish merchants wait alongside creels of freshly-landed cod to start bidding for the best fish.

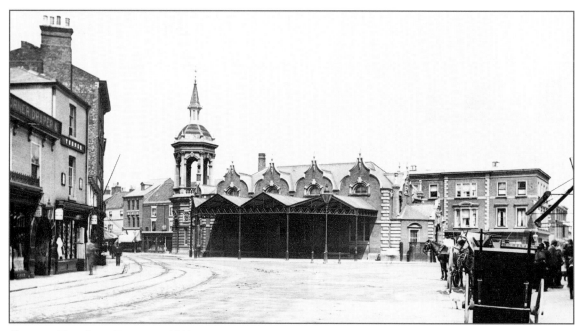

GRIMSBY, THE CORN EXCHANGE 1890 26725

At the time of this photograph, the Corn Exchange was still a hive of industry. The corn wagons were backed under the gantries where their loads would be auctioned off. The tramlines on the left differentiate this from photograph No G60015.

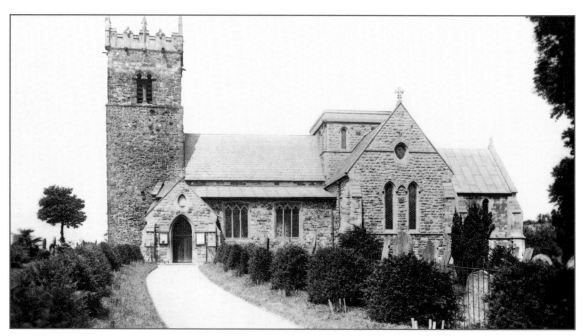

GRIMSBY, OLD CLEE CHURCH 1890 26713

Old Clee, which eventually gave its name to Cleethorpes, is now part of Grimsby, but still an old village round Holy Trinity Church. The church has a Saxon-Norman tower of unequal stages, but otherwise is mostly a restoration by James Fowler.

IMMINGHAM
Pelham Road c1960 I41001

Pelham Road runs all the way through the town; it is now built up on both sides of the road. The vehicles are up-to-date - a new Austin A30 van is delivering to the shop on the left. In the far distance beyond the road sign is now a housing estate.

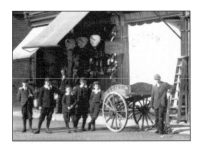

South of the Humber
North Lincolnshire

UNTIL 1981, CROSSING to the south into North Lincolnshire meant a detour of 30 miles inland, but with the construction of the Humber Bridge, the two banks of the estuary are now only minutes apart. The bridge itself is the longest single-span suspension bridge in the world, which is testimony to the engineering feats of today; the bad news is that the bridge is often closed owing to high winds!

North Lincolnshire is an area of 85,000 hectares bounded on the southern side by the Humber and split down its north to south axis by the River Trent. It is a largely agricultural area, and the age-old pattern of settlements reflects this, with market towns surrounded by many small villages. The important exception to this is the substantial urban and industrial area of Scunthorpe. Until the mid 19th century, Scunthorpe remained a small village. The discovery of iron ore in the district and the subsequent development of the iron and steel industries led to the rapid growth and urbanisation of Scunthorpe and its neighbouring villages. In 1936 the former villages of Scunthorpe, Ashby, Brumby, Crosby and Frodingham were incorporated to form the town we now know. With a population of 62,000 it is far and away the largest town in North Lincolnshire, and serves much of the area in terms of employment, colleges, retail and leisure facilities.

Eastward from the River Trent and Scunthorpe the early agricultural heritage is reflected in the development of historic market towns, including Brigg, Barton, Kirton Lindsey and Epworth. Farming may have been widespread; in earlier times it was very labour-intensive, for the work was done by sweat, toil and hand, but during the 1970s and 80s a change in work patterns resulted in high unemployment. The farms still prospered, but specialised hi-tech machinery meant that one man could do the work of many. Similarly, the demand for steel saw a decline, and the reliance on these two activities could no longer be taken for granted.

This stimulated a range of agencies to take action to regenerate the economy. The achievement to date was brought about through considerable investment by central and local governments. Improvements to communications by extending the M18 and M180 and intensive marketing of the area meant that new industry was attracted here. This was predominantly light manufacturing seeking greenfield sites, a UK location and a reliable work force. The cynical might say that the generous financial incentives also played a major role in attracting more multi-national companies and plcs.

The current picture of the local economy now looks very different. The rise in employment opportunities is reflected in there being much lower unemployment than there was ten years ago. Steel is still the major employer with 33 companies and 8,000 staff, but food production has been overtaken, in terms of numbers employed, by electronics and petrochemicals.

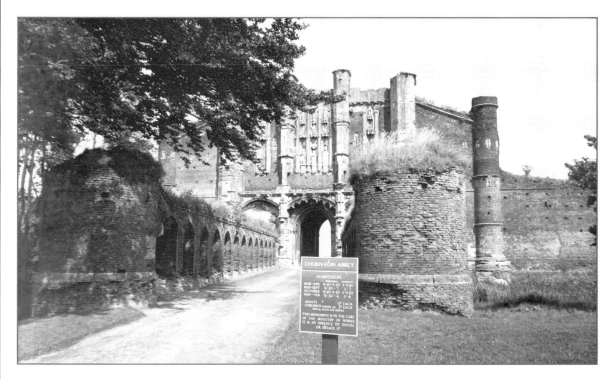

GOXHILL, THORNTON ABBEY c1960 G158019
Founded in 1139, the Abbey was one of the wealthiest houses of its order. Henry VIII stayed here with Katherine Howard shortly after its dissolution, but now the ruined Chapter House and great church are a stark reminder of the centuries of destruction following its closure in 1539.

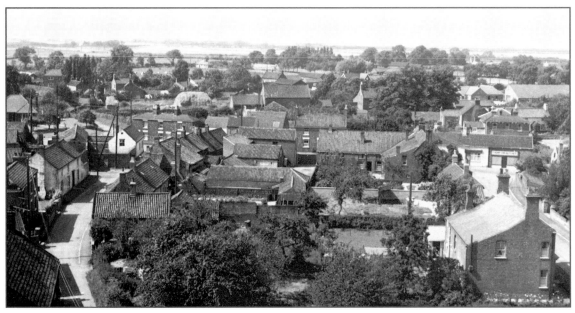

GOXHILL, GENERAL VIEW c1960 G158017
Goxhill's most notable building is the church of All Saints, which is of 15th-century origin. The Priory lies about a mile away. It has never been used as a priory, but is a secular building, possibly a manorial chapel of St Andrew belonging to the De Spenser family. The town name is from the Old English 'Geacesleah', meaning 'cuckoo's wood or glade' ('geac' -cuckoo, 'leah' - wood).

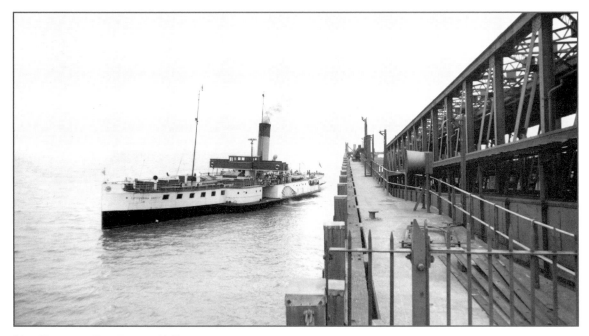

NEW HOLLAND, THE FERRY c1955 N99001
The 'Tattershall Castle' was one of many paddle steamers that ferried passengers across the Humber prior to 1981 when the Humber Bridge was completed. It was a regular fifteen-minute service, but only when the tide was in, as the Humber is a tidal estuary. Anyone needing to get to Hull had to be aware of the tide tables!

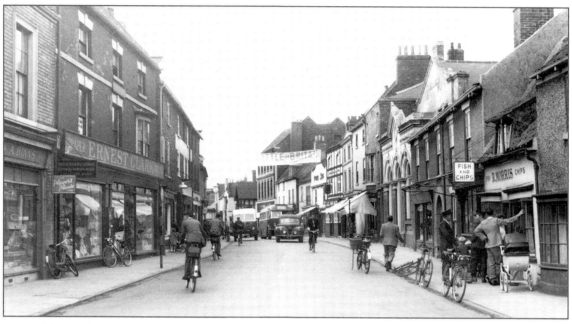

BRIGG, WRAWBY STREET 1954 B294011

The cyclist is still dominant, but even at this time there is the forerunner of a traffic jam with the Humber overtaking the parked Commer van. The picture would have been taken in August, as the banner bears the slogan 'Battle of Britain', which was celebrated every year following the original battle in the late summer of 1940.

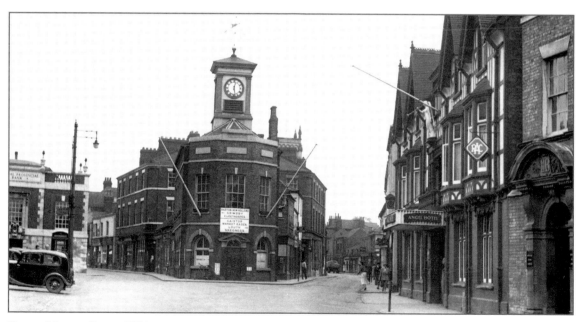

BRIGG, MARKET PLACE 1954 B294022

This is now a pedestrian precinct. We can see the Midland (HSBC) Bank to the front right and the National Provincial (NatWest) to the far left. The market hall also serves as a convenient road sign, indicating Grimsby to the left and Skegness to the right. This indicates that the correct speed of traffic, as much as on keen eyesight, was needed to turn the right way.

SCAWBY, THE VILLAGE c1960 S772011
More accurately, this is the rear of Church Street; modern detached houses have been developed in the allotment-style gardens. If you think there is a rather large white gravestone in the church graveyard, you are wrong: it happens to be the village pump.

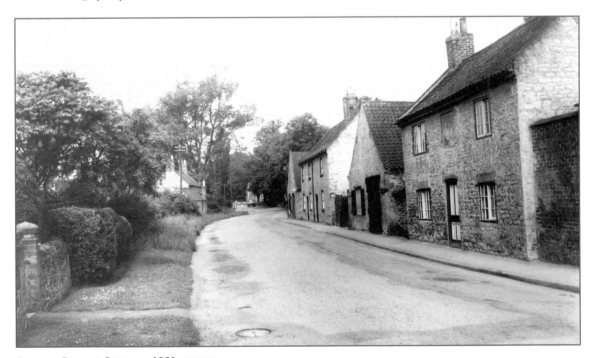

SCAWBY, CHURCH STREET c 1960 S772009
The houses on the left adjoin the church and were built in the 18th century as almshouses. The road looks in need of re-surfacing; it would have been a definite danger to the cyclists of the time.

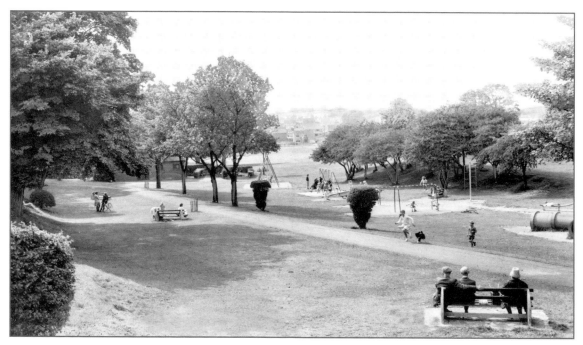

ASHBY, MANOR PARK c1965 A171030

It would be a pleasure to say that nothing has changed here - as in many of the Frith pictures. Unfortunately, that would be economical with the truth. Manor Park is now a housing estate.

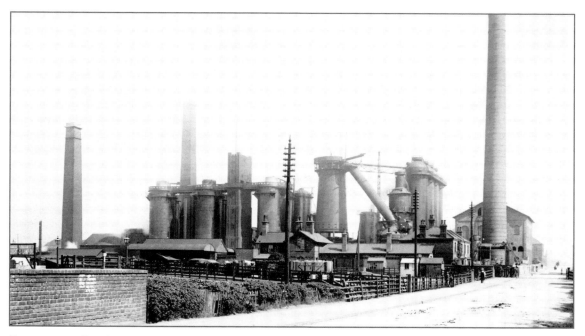

FRODINGHAM, THE IRON AND STEEL WORKS 1904 52166

Following the discovery of iron ore, the village of Scunthorpe grew rapidly, swallowing up places like Frodingham. The works shown are still here, but the plant has been modernised. It was nationalised during the war to become part of British Steel, then privatised in the 1980s and is now owned by the Corus group.

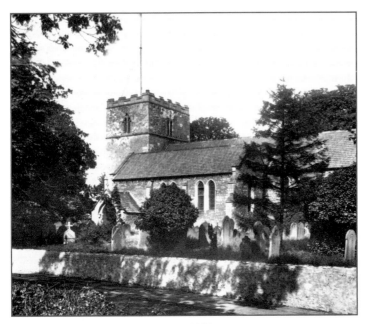

FRODINGHAM, THE PARISH CHURCH 1902 49013

FRODINGHAM
The Parish Church 1902
There has been a church here since Norman times, but since this photograph was taken a local museum has been built in the grounds. However, its most unique feature is that it also incorporates Braille signs for the blind.

◆

SCUNTHORPE
Frodingham Road c1965
We are looking towards Frodingham. This photograph shows how built up the area had become. The Parish Church is just visible in the far distance, whilst the spire of the Holy Soul Roman Catholic church can be clearly seen on the left.

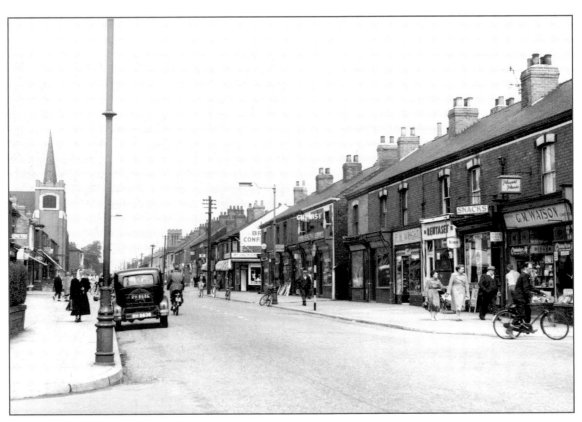

SCUNTHORPE, FRODINGHAM ROAD c1965 S78031

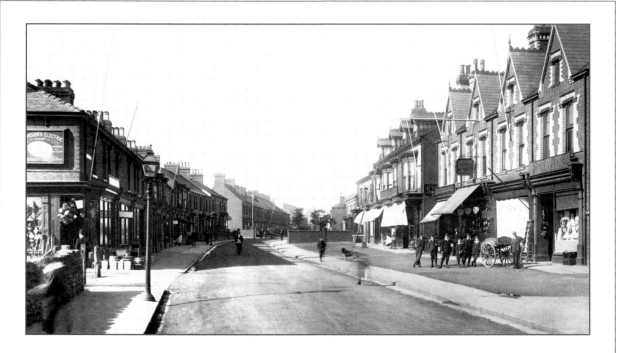

SCUNTHORPE

Frodingham Road 1902 49011

Frodingham Road was a continuation of High Street on the way out of Scunthorpe. Then, as today, the better class of shops attracted the more affluent in society. Freeman, Hardy and Willis can be seen just behind the group of boys.

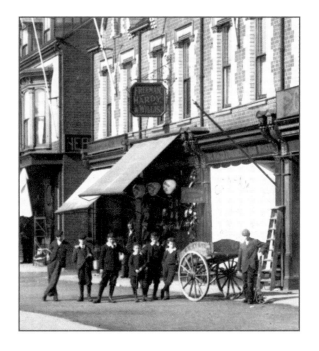

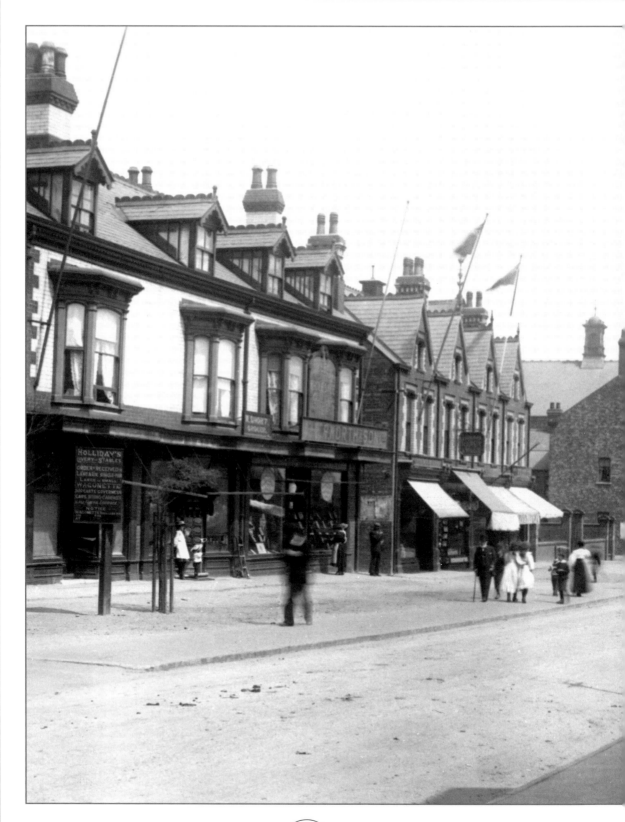

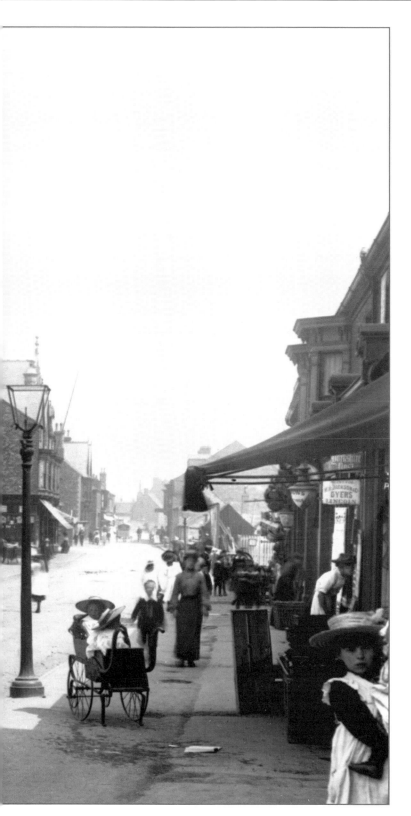

SCUNTHORPE, 1904 52158
This scene is indicative of the time - there is not a car in sight. Indeed, the sign on the left is for Holliday's Livery and Stables, where you could also hire a landau or dogcart.

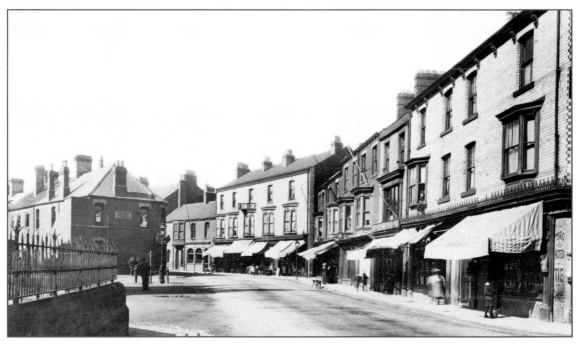

SCUNTHORPE, HIGH STREET 1902 49008

This part of the town seemed to specialise in tailors' and dressmakers' premises. The Noted Tie shop is first on the corner, with Dunn's gentlemen's outfitters being in the centre of the picture.

SCUNTHORPE, KINGSWAY GARDENS C1965 S78058

This area has luckily not changed at all. The houses on the right were newly-built, and would have been in great demand with such a view of the gardens. They also seemed to have an excellent bus service. A single-decker is closely followed by a double-decker.

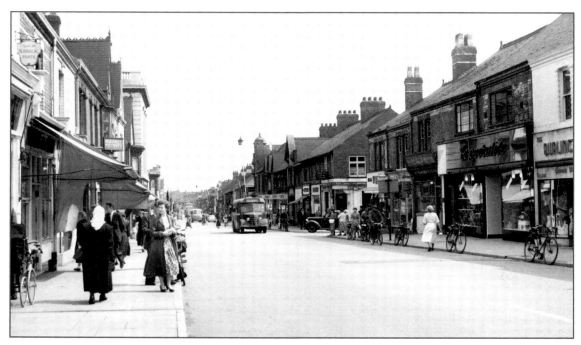

SCUNTHORPE, HIGH STREET c1965 S78032
This is a useful spot in the street: the Post Office is on the left, the Trustee Savings Bank is adjacent to the bus, and the shiny new frontage of the Co-op is second on the right.

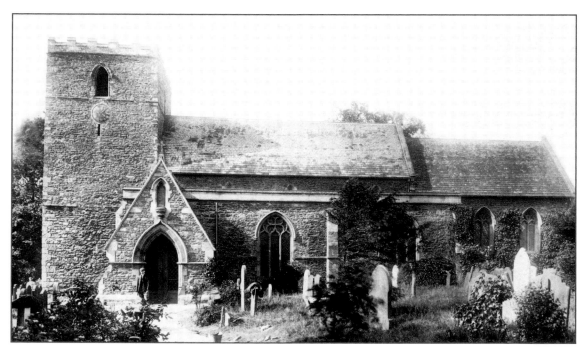

SCUNTHORPE, BURTON CHURCH 1904 52169
Burton would have been a separate village at this time, but now it is just a suburb of Scunthorpe. A lone workman surveys the task of concreting the pathway down to the church door.

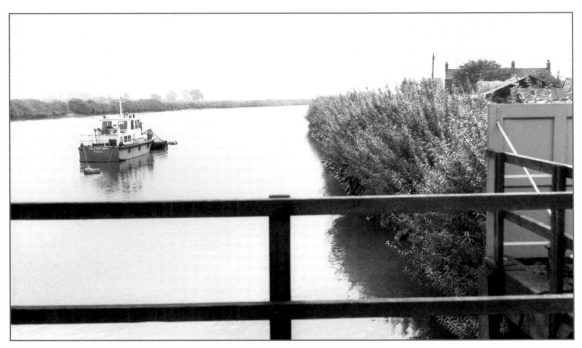

OWSTON FERRY, THE RIVER c1955 068024

Before the coming of the car, taking the ferry north up the River Ouse into Hull was the quickest and easiest route. Today it would be the more pleasant way, but the ferry runs only spasmodically. The ferry boat shown is the 'Trisantona'.

EPWORTH, CHURCH STREET c1960 E117014

As the birthplace of John Wesley, the whole of Epworth is now a conservation area, with the strictest of planning regulations. Therefore there has been virtually no change in the forty years since this photograph was taken.

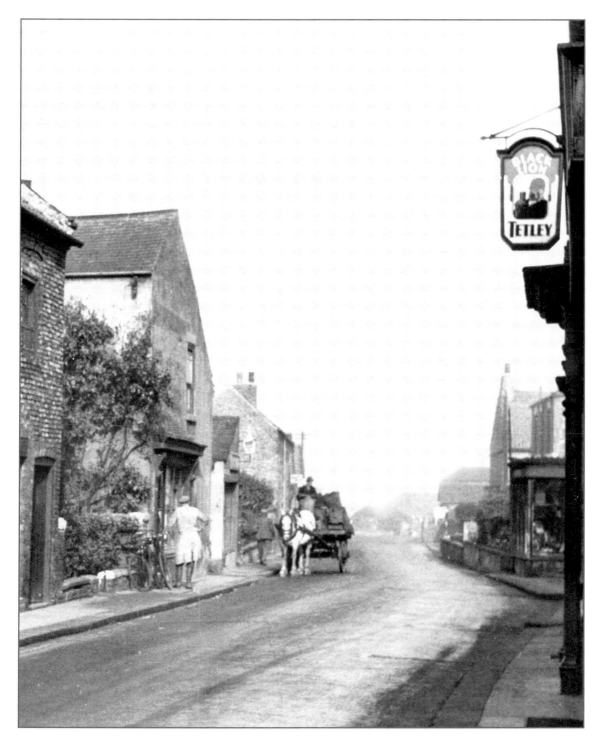

SNAITH, SELBY ROAD c1950 S402004
The name of this thriving village means 'enclosed by water', and the area is locally known as the Three Rivers region. The old village cells, or lock-up, The Penny Cells, have been lovingly restored by the local Heritage Society, and art and craft exhibitions are held there.

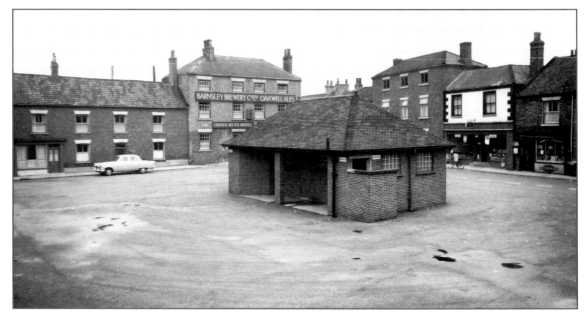

CROWLE, THE MARKET PLACE c1965 C346014
The only thing that can be said about the horrendous building in the centre is that it served a useful purpose - a toilet block. Fortunately, this blot on the landscape has now been flushed away. The market continues, but it is now more of a flea market and car-boot sale. The Barnsley Brewery is once again thriving, thanks to the resurgence of real ale, but the Cross Keys is now a John Smith's pub.

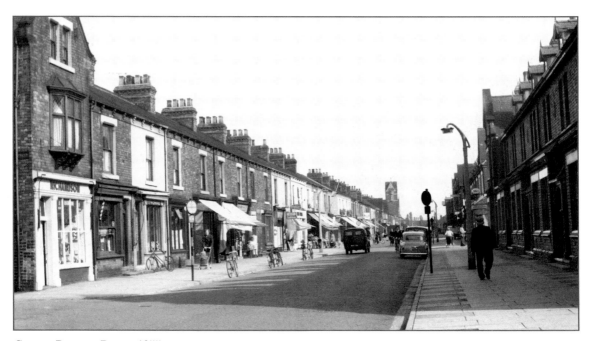

GOOLE, PASTURE ROAD c1955 G157011
Pasture Road has been recently re-paved, but it is still the location for many of the local retail businesses. In recent years it has held highly successful Christmas events which see the road closed to traffic and a street fair held.

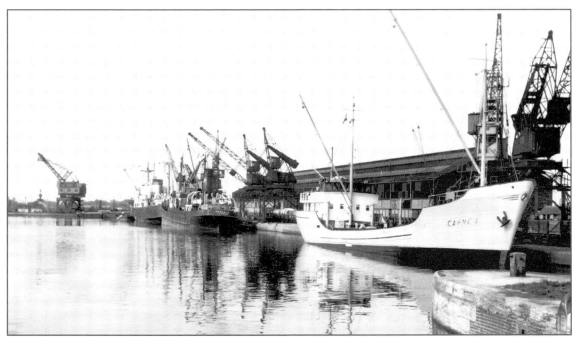

GOOLE, THE DOCKS c1955 G157015

The port has seen many changes since its beginnings in the mid 1800s. As an inland port, situated at the centre of the UK, it is an ideal import/export point for Europe and the rest of the world.

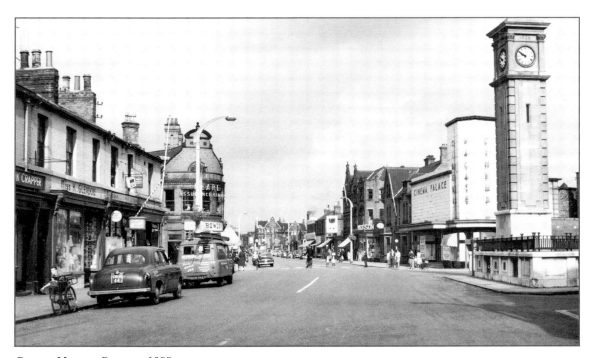

GOOLE, MARKET CENTRE c1955 G157023

The Clock Tower is a modern structure built in 1945 to commemorate the end of the war; to the rear is the Victorian Market Hall. It is nice to see the Palace open as a real cinema before the onset of the multi-screen visual supermarkets.

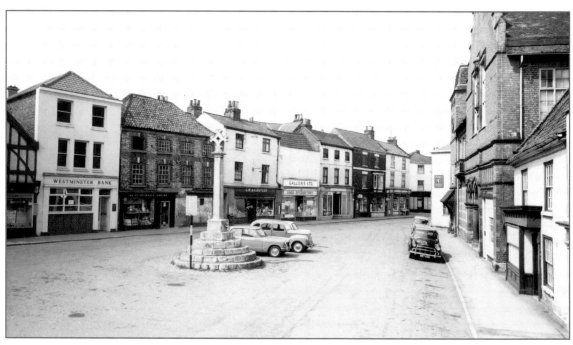

HOWDEN, THE MARKET PLACE c1965 H274026
The cross, between the Westminster Bank and the White Horse Hotel, stands on a medieval stone base. A Grade II listed monument, it was replaced by a street lamp in 1909.

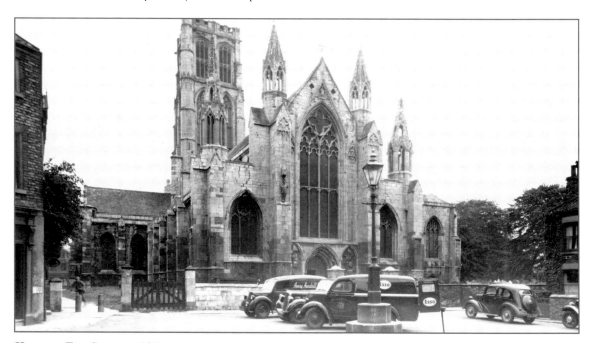

HOWDEN, THE CHURCH c1955 H274008
The church of St Peter and All Saints was originally built in Anglo-Saxon days; indeed, it is mentioned in the Domesday Book. So much was re-built and added during the following centuries that the sense of age has gone. It is now known throughout the area as The Minster.

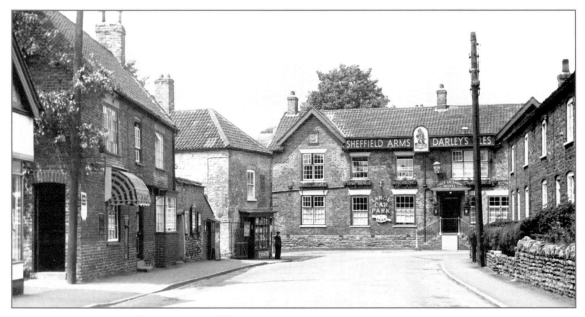

BURTON UPON STATHER, HIGH STREET c1955 B434002

The Sheffield Arms dominates the scene, and still does to this day. The corner shop has gone, and Darley's Ales are not available - the hostelry is now part of the Pubmaster chain. For the pub to be advertising a 'large car park' at this date suggests that the clientele came from outside the village, and that they were somewhat up-market to be car owners in the '50s.

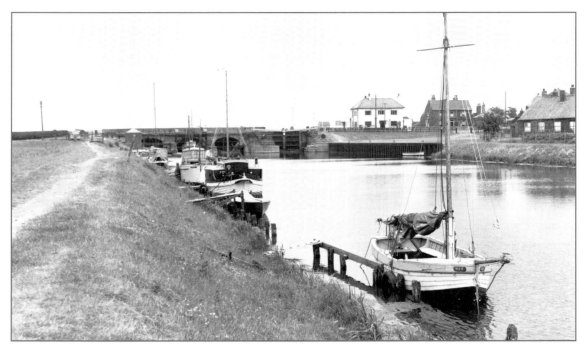

SOUTH FERRIBY, THE RIVER ANCHOLME c1965 S404024

The River Ancholme is an angler's paradise; it is abundantly stocked with coarse fish, especially roach and bream, and recently perch. In the background is the sluice and tidal lock where this tributary tumbles into the Humber.

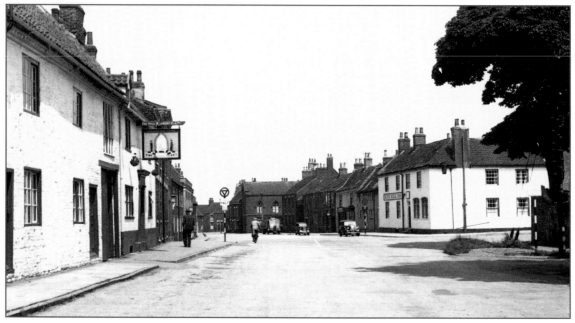

BARTON UPON HUMBER, WHITECROSS STREET c1950 B750308

Nestling on the south bank of the Humber, the wide boulevard of Whitecross Street has changed little. The Volunteer Arms remains much the same, but the charmingly named Blue Bell has fallen victim to the era of theme pubs, and is now known as Cook's Bar.

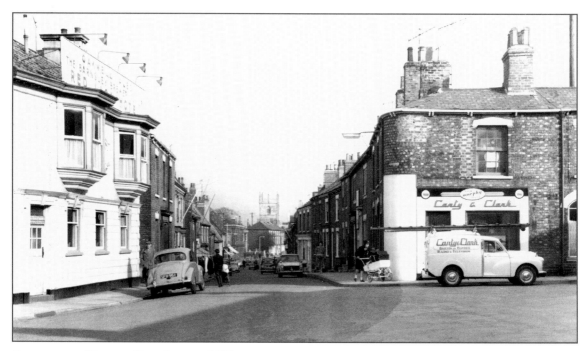

BARTON UPON HUMBER, HIGH STREET c1955 B750006

This photo is slightly later than the above photograph; there is not much change to the High Street, but the cars are now looking recognisably modern - note the Morris 1000 saloon and van in the foreground.

Hull

'From Hull, Hell And Halifax - Good Lord Deliver Us'

HULL, OR OFFICIALLY Kingston upon Hull, is situated on the north bank of the River Humber where the River Hull flows into it. It is an ancient city granted a Royal Charter in 1299. Thus Kingston was originally King's Town, named after King Edward I; it has always been a far-sighted place, overtaking Liverpool to become the third largest port in the country after London and Southampton. It foresaw the coming of roll on/roll off freight traffic, and by the building of the Queen Elizabeth dock in 1971 was able to capitalise on the growth of exports direct from the industrial North to Europe. Also, with the millions of people living along the M62 corridor combined with the popularity of European holidays, Hull soon became the second largest carrier of tourists after Dover, with daily luxury ferries sailing to Zeebrugge and Rotterdam.

Hull's other main industry was also of a sea-faring nature: deep-sea fishing. It is regrettable that it is now in decline owing to over-fishing by most European countries. This decline has meant that over the past decades the city has diversified into a multitude of modern industries, including pharmaceuticals, chemicals, electronics and aircraft construction.

A modern bustling city centre with excellent shops and modern office blocks shares the skyline with grand Victorian merchants' houses. Near the waterside is the picturesque 'old town', where historic buildings nestle cheek by jowl with street cafes lining the cobbled streets of Hull's traditional heartland where the River Hull joins the Humber.

The tourist and conference industries are now increasingly important employers in Hull, and with the announcement of the city's flagship Millennium project 'The Deep', this trend is set to continue. This £37 million science and visitor centre is expected to attract millions of visitors, thus raising the city's profile and creating new jobs. This premier tourist showcase, soon to be finished, will be a demonstration of the significance of Hull's regeneration. The success of the tourist industry is a tribute to both to the improvements made and to the city's ability to re-brand itself.

Hull has produced many famous sons, the most prominent of whom were John Wesley and the anti-slavery campaigner, William Wilberforce. Paradoxically, though, for a world-famous port there were few seafaring explorers; but there were a plethora of literary alumni, beginning with Andrew Marvell and continuing through Winifred Holtby (is it any coincidence that her best known novel was 'South Riding'?) up to the present day with Alan Plater, John Godber and the recent Poet Laureate, Philip Larkin.

The opening quotation comes from 'The Beggar's Litany', by another Hull poet, John Taylor, and is a reference to the two 'gibbets' of Hull and Halifax, which were predecessors of the guillotine; they were used to behead stealers of cloth valued at 13 old pence or more - a heavy penalty for petty theft. So between 1541 and 1650 the laggards and criminal fraternity of the time knew which two towns in the country to avoid.

Land of Green Ginger?

IT WOULD BE a gross oversight to leave Hull without mention of 'Green Ginger', as many people, not just Northern folk, are aware that certain parts of the city and environs are associated with the 'Land of Green Ginger'. True, Winifred Holtby wrote a novel of the same title, and the present Tourist Office in Hull is situated in Green Ginger Street, but these names certainly came after the original legend. One of the reasons for the on-going interest in the name is that there is no authoritative explanation.

There are two commonly-held views as to the origin. A generation ago, the generally-accepted one was related to the name of a local boat-builder, one Moses Greenhinger, who lived some three hundred years ago. During recent years much has been written to discredit this theory, and various others have been suggested. Some have related the name to a Dutchman, Lindergren Jonger, who is believed to have lived in the neighbourhood. Yet others think that the name came into being through a wealthy merchant who made a fortune out of green ginger landed in Hull close to this spot. As with all good folk legends, the truth lies somewhere in between.

The most likely explanation is that since Hull was a walled city and large stocks of fresh meat and fish had to be stored, various herbs such as thyme, marjoram and mint were used to preserve the precious food. Another herb, ginger, before it ripens is green in colour, and it made an ideal preservative. Hence Green Ginger. I rest my case!

HULL, PARAGON STREET 1903 49815
It is no accident that Paragon Street was the centre of entertainment, as 'paragon' means 'supreme'. It is likely that the railway station of the same name predates this picture by sixty years. The Theatre Royal, previously the Tivoli, was demolished in 1957, but the Grand still stands, albeit as an office block.

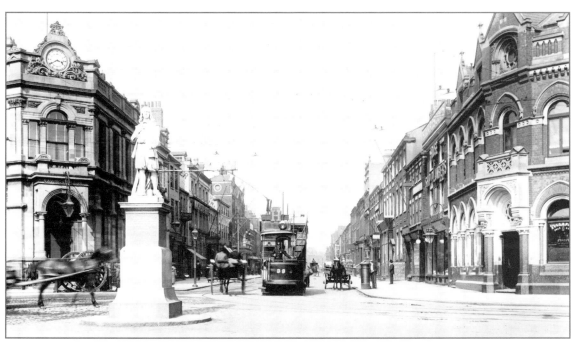

HULL, GEORGE STREET 1903 49814

The statue of Hull's leading writer, Andrew Marvell, has been moved; George Street became the new centre of entertainment. Bars, bistros and night clubs flourish here.

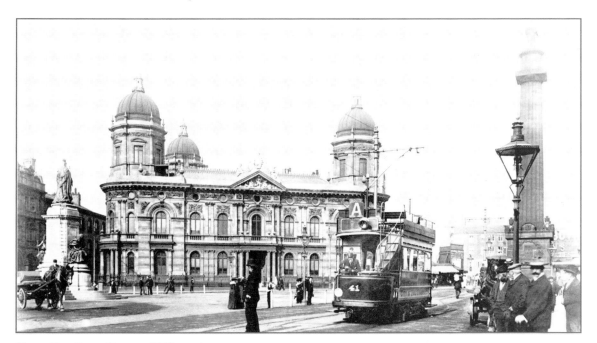

HULL, THE DOCK OFFICES 1903 49807

This whole area is now a pedestrian precinct, where Queen Victoria (far left) now has a more peaceful view. The Dock Offices are now a whaling and maritime museum, but there was not room for the towering statue of the anti-slavery MP, William Wilberforce. He was moved to the grounds of Hull College.

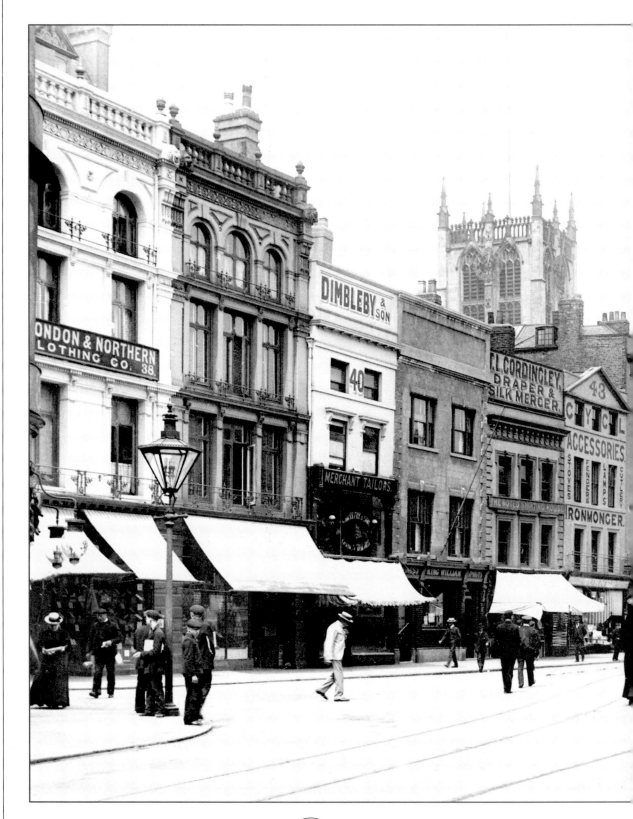

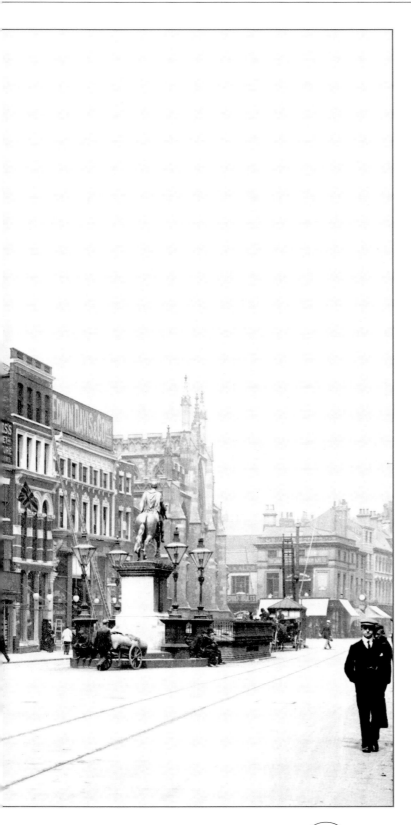

HULL, MARKET PLACE 1903 49813
The statue of William III, originally erected in 1734, stands proudly in the centre, bisected by the tramlines. William has moved several times over the years; he now sits above a Gents urinal. The tower of the Holy Trinity Church peers over the fine silk and jeweller's stores.

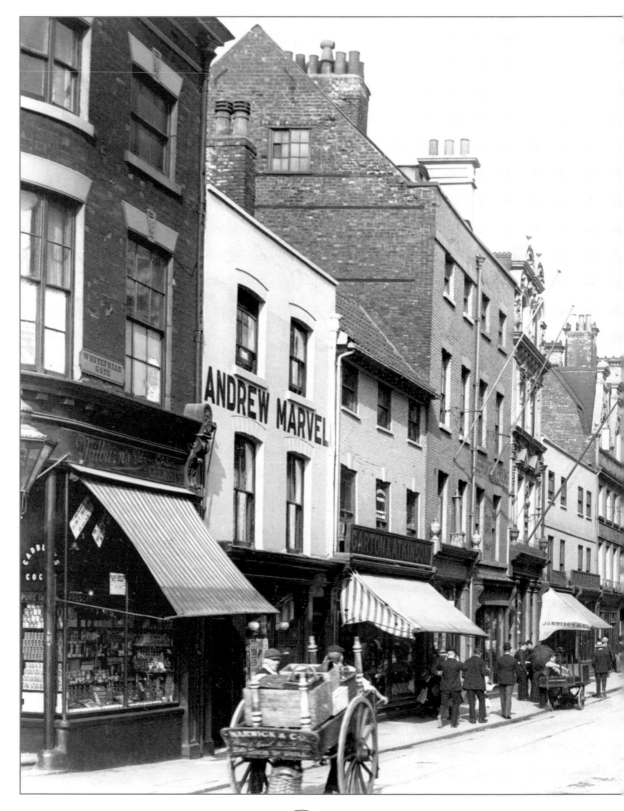

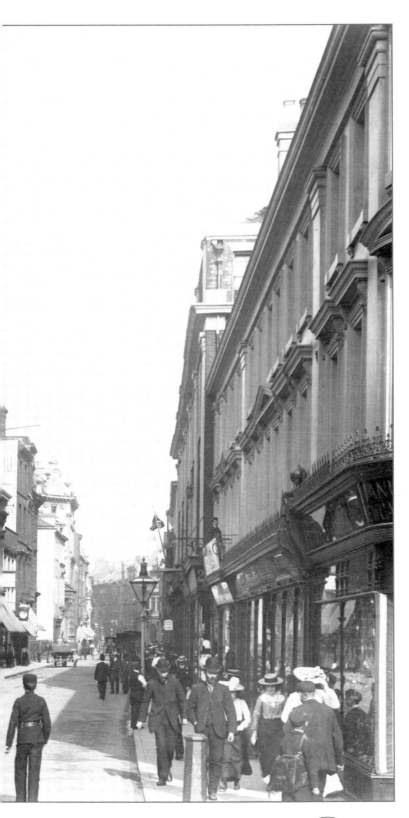

HULL, WHITEFRIAR GATE 1903 49817
This narrower street leads on to the
Market Place, and is now
pedestrianised. The Andrew Marvel
public house on the left is either a sad
misspelling of the great man's name, or
an early advertising ploy. Then again, it
could be the sign-writer's fault in not
allowing room for the second L.

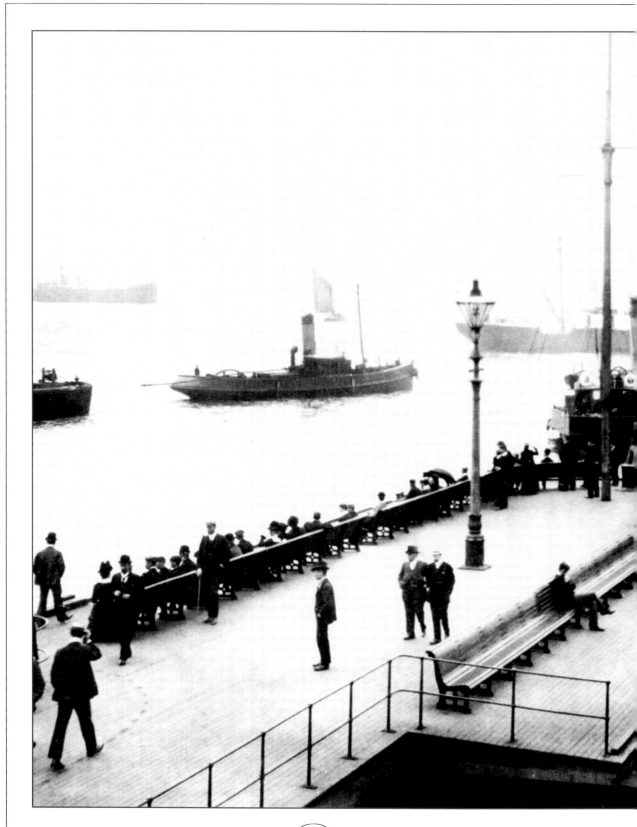

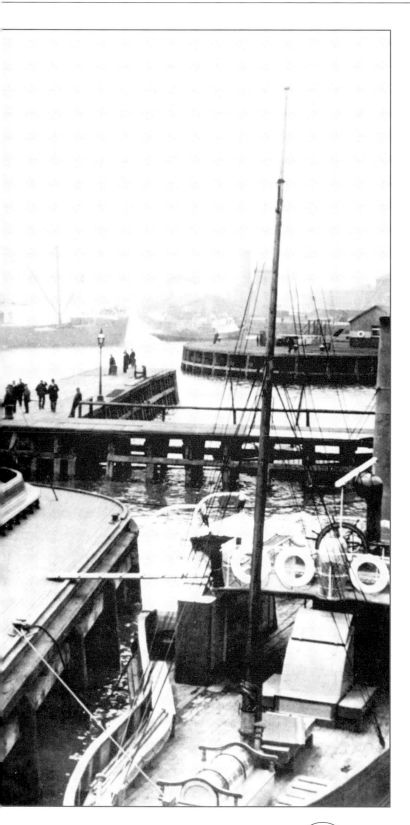

HULL, THE HUMBER 1903 49820
This area is now called the Marina; the Humber is still a busy working area. However, the promenade area has been taken over by the ubiquitous bistros and wine bars.

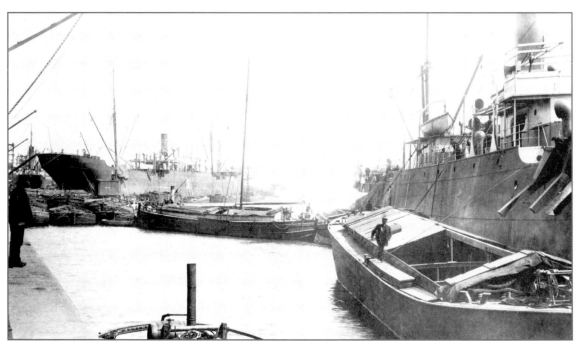

HULL, ALEXANDRA DOCK 1903 49825
The hustle and bustle of the barges and ships in this picture are now a thing of the past. The whole dock area has been Grade II listed, but little happens here now.

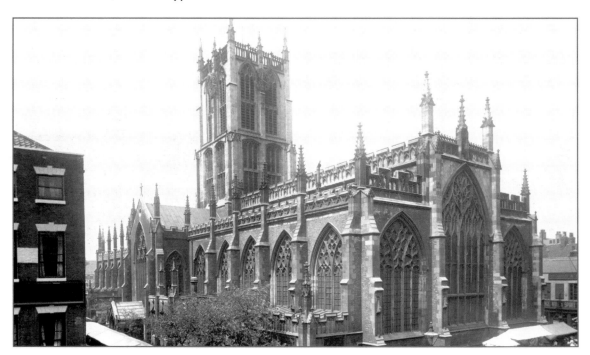

HULL, HOLY TRINITY CHURCH 1903 49826
Overlooking the Market Place, the church has fallen into a badly neglected state. The fabric of the building needs urgent repair, and if the money is not found then it may well have to be demolished.

KEYINGHAM, THE CROSS c1955 K105002

The village lies some nine miles from Hull. Near the centre of the village is the base of an ancient cross, consisting of the lower part of the shaft and elevated on three steps. On the sides are blank shields. The photographer pictured the structure at such an angle that it appeared as if the telegraph pole was mounted on the Cross!

KEYINGHAM, THE CROSS c1955 K105001

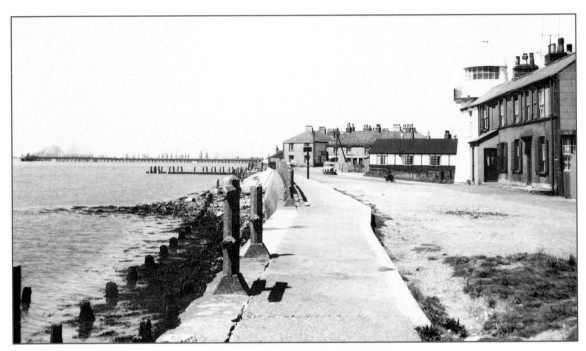

PAULL, THE WATERFRONT c1960 P185006
Just a couple of miles east of Hull, Paull is renowned for its ship-repairing skills. A small but nasty reef induced Trinity House to erect a small lighthouse here in 1836. It was sold off in 1993.

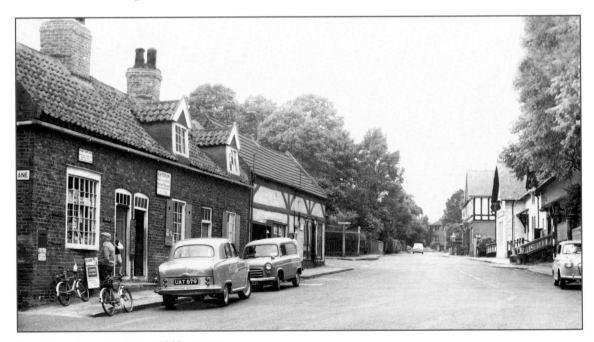

KIRK ELLA, PACKMAN LANE c1960 K107003
This hamlet, some five miles north-west of Hull, was one of the first places where the wealthy merchants of Hull built their elegant country homes. Adjacent to the Post Office are the premises of one A H Tuton - High Class Grocery and Provision Merchant.

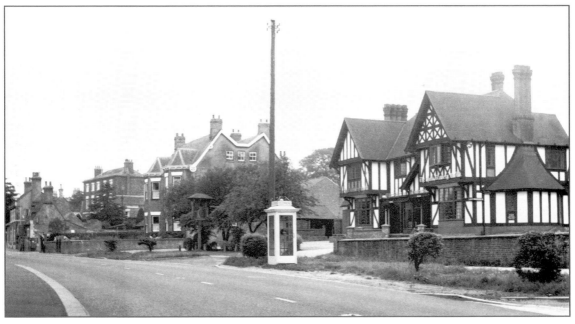

NORTH FERRIBY, YE OLDE DUKE OF CUMBERLAND c1960 N102008
The pub is not very old, and has little history. The most interesting object is the white, decorative telephone box by the roadside. Kingston-upon-Hull was until very recently the only place in the UK to have its own local telephone exchange, and it therefore had its own unique telephone boxes.

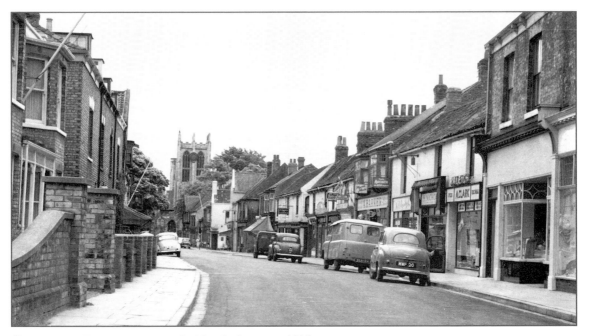

COTTINGHAM, HALGATE SHOWING ST MARY'S CHURCH c1965 C344055
'Hal' or 'Hallgate' - the spelling may change, but it is the same place. The church was built between 1316 and 1416, and originally had five bells. Edward IV, who must have needed some cash, had an inventory done on all the churches in England. It was reckoned that Cottingham only needed four bells, so one was sold off: it raised £25 at auction.

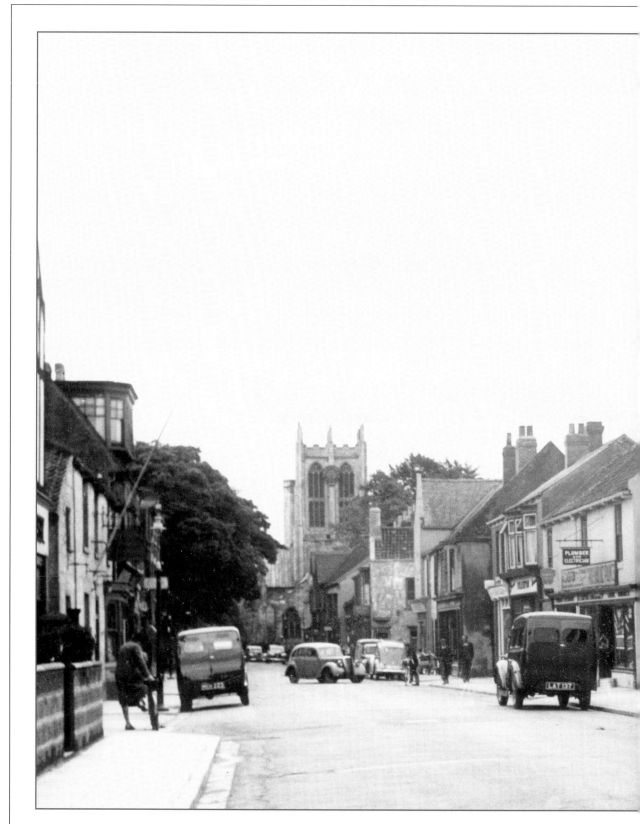

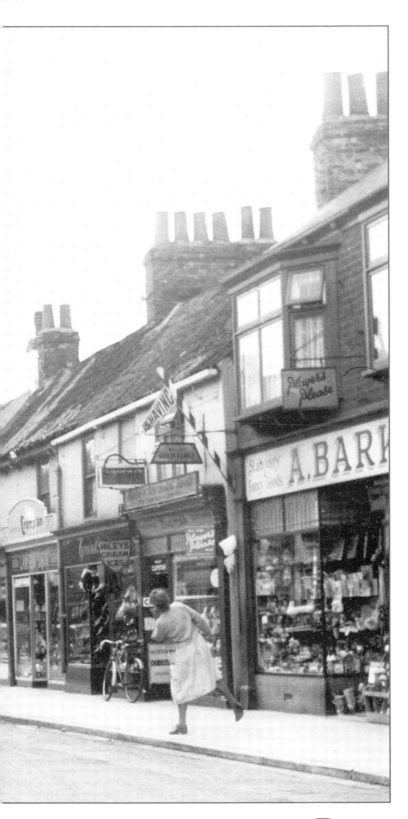

COTTINGHAM

HALLGATE c1955 C344012

It is often said that this place is the largest village in England. The coming of the railway in the 19th century turned it into one of the more genteel suburbs of the city. The parade of local shops is typical of these times, but the gentility has faded somewhat in recent years with a plethora of 'To Let' signs and charity shops.

COTTINGHAM, FERENS HALL c1965 C344065
Ferens Hall was built as a minor stately home, but by the time of this picture the owners were crippled with debt.
Hence it was donated to the University of Hull, where it now accommodates 181 students in single rooms.

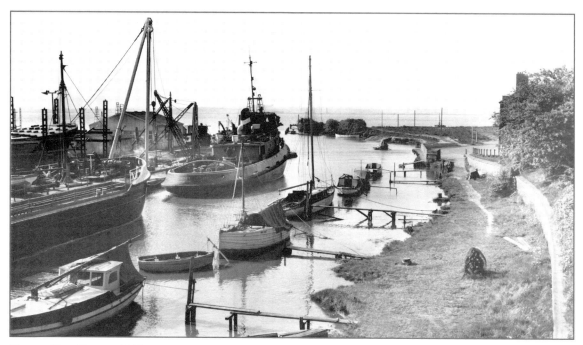

HESSLE, THE HAVEN c1965 H467022
The wharf still exists, but with very few boats moored there now. However, the area gained a new landscaped park (to the right) created for the Queen's visit in the 1980s.

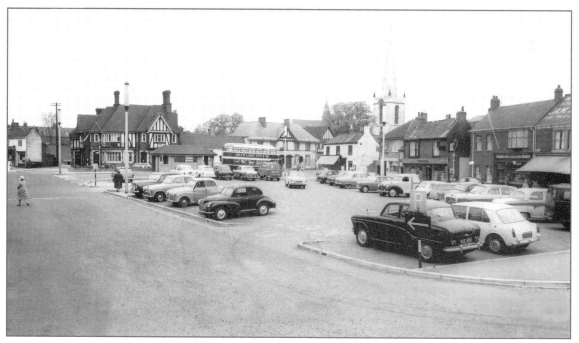

HESSLE, THE SQUARE c1965 H467009
The Square still exists, but it has been largely paved over with parking for a few cars. The Granby public house is still here, as is the spired church of All Saints.

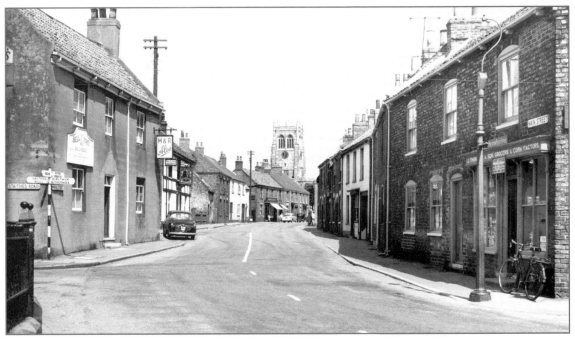

PRESTON, MAIN STREET c1960 P187016

This is actually the cross-roads in Preston where the Hull to Withernsea road passes through the village. It is two miles east of Hull near Hedon, and is overlooked by a church with a now familiar name - All Saints.

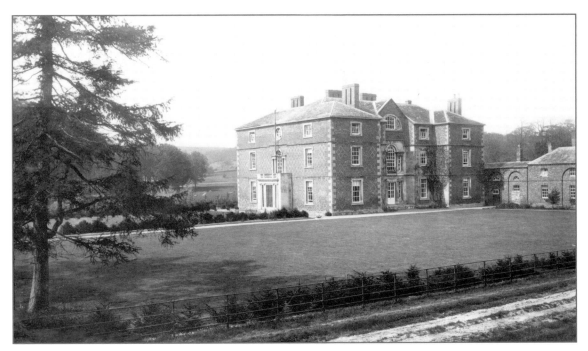

BOYNTON HALL c1885 18030

A stately Georgian residence, this is now the home of Richard Marriott, the Lord Lieutenant of the East Riding. The house and grounds were featured in the 'Yorkshire Life' magazine in 1996.

The East Riding of Yorkshire

THE EAST RIDING is by far the largest of the five sections of this region. It covers some 933 square miles, making it England's biggest unitary authority by area, and is home to 312,000 people. The largest town is Bridlington with a population of 32,000, closely followed by Beverley at 25,000, Goole at 18,000 and Cottingham at 16,000. But over half the population lives in rural communities, many of which are small, scattered and geographically isolated. (And whilst we are talking numbers here, the gardens at Burnby Hall boast Europe's largest collection of water lilies: over 5,000 flower in the two acres of lakes).

The landscape is unlike anywhere else in Britain, and is truly a walker's paradise. Rich and fertile farmland swells gently from the flat meadows of Holderness, gradually rises and rolls over the chalky uplands of the Yorkshire Wolds, to end with a flourish at the great chalk cliffs plunging down into the North Sea at the dramatic site - and sight - of Flamborough Head.

Historically, the East Riding has been populated since the earliest times. Remains of rhinoceros, hippopotamus and straight-tusked elephants have been excavated at Sewerby, suggesting a warmer climate in the past, possibly prior to the last Ice Age, 10,000 years ago. In around 300 BC the Gauls arrived, bringing Iron Age technology to the area; then came the Romans, followed in due course by the Angles and Vikings, who were more into pillaging than

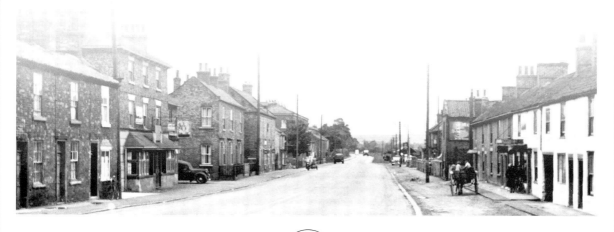

developing the land. Development was left to the Danes; they named the whole of Yorkshire the kingdom of Deira, and divided it into thirds which they called 'tredings' or 'thridings', and thus the Est Treding or East Riding was born.

In 1399, Henry Bolingbroke landed on the east coast with the intention of sending the Danes packing and claiming the crown of all England. This he did, and became Henry IV - the subject of Shakespeare's play. Whilst the East Riding has welcomed many visitors over the ages, there have also been a number of departures. Since Roman times, thirty villages along the coast have disappeared as the sea reclaims the clay soil deposited at the end of the last Ice Age. This coastal erosion is still continuing, and at an alarming rate: in one particularly stormy night, six metres vanished.

In summary, the East Riding is a county of contrasts, from the rich agricultural Wolds to the wild chalk headland of Flamborough. Historical market towns are dotted across the area, notably Driffield, Beverley and Market Weighton. The coastal towns of Bridlington, Hornsea and Withernsea, with their safe sandy beaches and fishing heritage, have long been popular with Yorkshire people as holiday and day-trip destinations.

SWANLAND, THE POND c1965 S408037
There has been a pond here since at least 1772. The swans were introduced later; thus there is no mystery regarding the origins of Swanland.

SWANLAND, THE POND C1965 S408015
The Congregational Church and Institute were originally built in 1803, with adjoining wings added in 1854. The church organised the first-ever Sunday school in the East Riding.

BROUGH, STATION ROAD C1960 B765016
In Anglo-Saxon this place was known as 'burh', meaning 'fortified place'; its present prosperity rests firmly in the 20th century. The Blackburn Aircraft Company opened its first factory in 1916; as the company expanded, becoming a major employer, many more people were attracted to the thriving village.

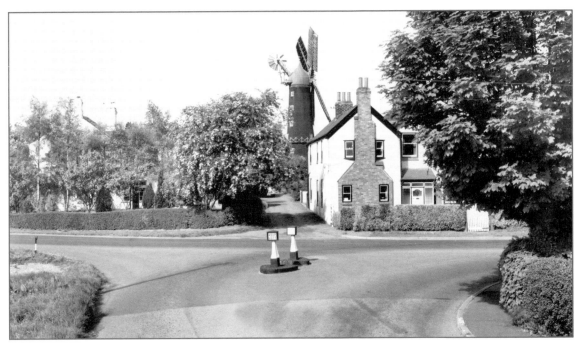

SKIDBY, THE MILL c1965 S398099
The fully restored and working windmill here in the centre of Skidby is now a museum and tea-rooms, both of which are owned by the East Riding council.

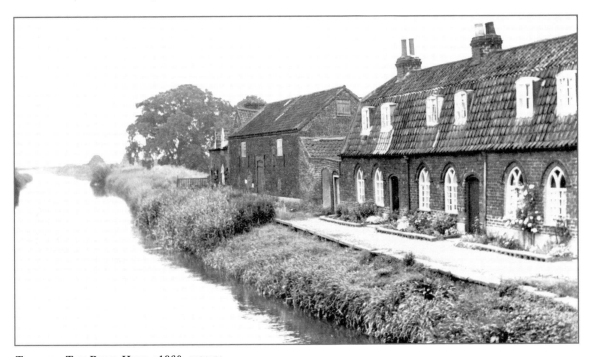

TICKTON, THE RIVER HULL c1960 T170009
This picturesque hamlet is no more than a collection of houses on the banks of the River Hull. This is rather confusing, as at this point the Hull is part of a canal - the Driffield Navigation - that is made up of a number of linked waterways.

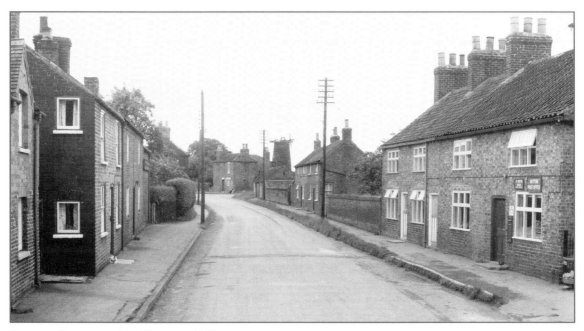

HUTTON CRANSWICK, THE VILLAGE c1960 H275005

This is something of a misnomer, as in reality there is no such village. The fact is that there are two villages, Hutton and Cranswick, which are less than a mile apart. Hutton is the smaller, and stands on a slight hill. This is reflected in its Norse name - 'Hoot' - hill and 'tun' - an enclosure.

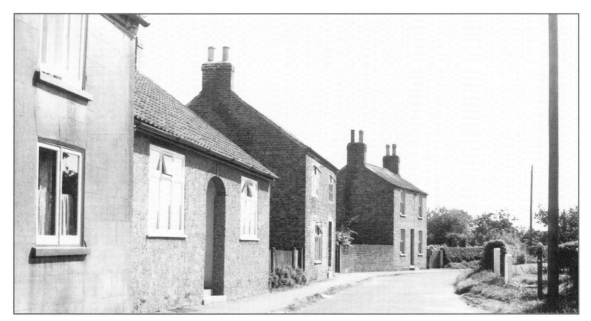

CRANSWICK, THE VILLAGE c1960 C345008

Like its neighbour, Cranswick dates from the time of the Norsemen, and was originally the site of a 'wic' or military encampment. Cranswick was on the site of the Hull and Scarborough railway until the Beeching days of 1963. The village was a centre of non-conformist worship: it had Primitive Methodist, Wesleyan and Baptist chapels all within the space of a few hundred yards.

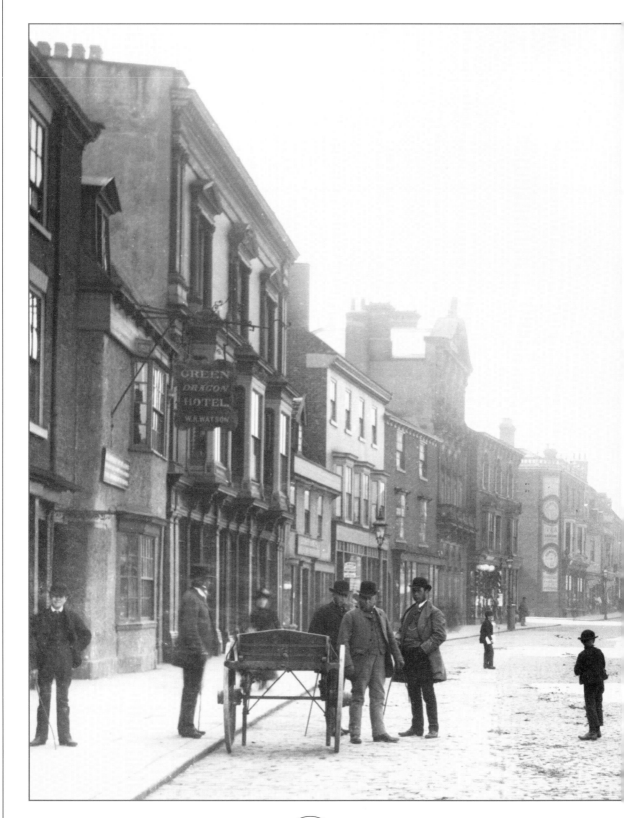

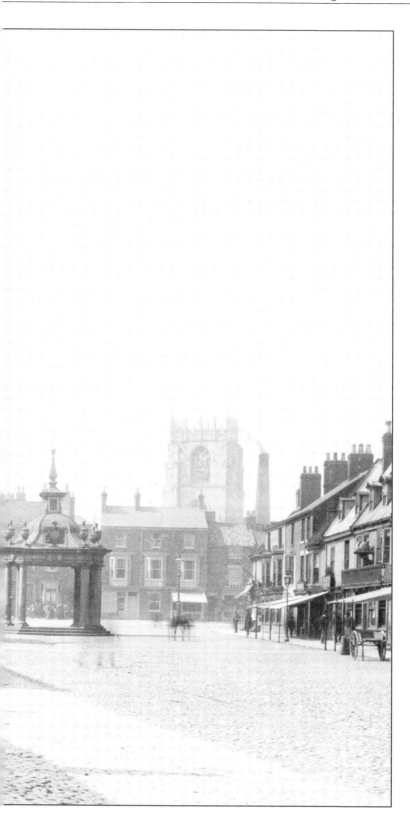

BEVERLEY
THE MARKET PLACE 1886 17885
In the Saturday Market is a market cross built in 1714. It is an open octagon with pillars supporting the domed roof, which displays the arms of England, France and the two local Members of Parliament who donated it.

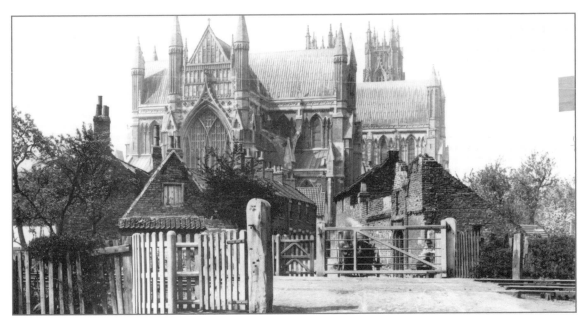

BEVERLEY, THE MINSTER, THE EAST END FROM CHANTRY LANE 1886 17872

There is no disputing the claim that the Minster is one of Europe's most beautiful and finest churches. The Early English east end was begun in 1220, and the magnificent Perpendicular west front, with its richly pinnacled towers, was completed in 1420. Inside, amid the immense display of ornament and sculpture, is a rare stone sanctuary chair known as the Frith Stool.

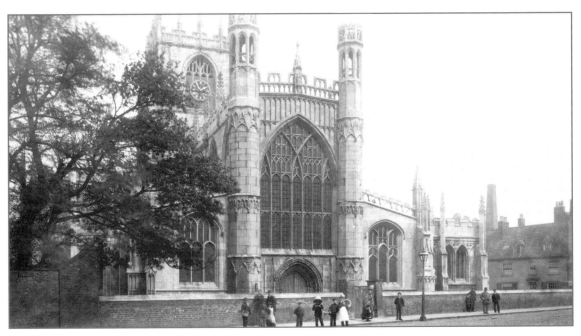

BEVERLEY, ST MARY'S CHURCH, THE WEST FRONT c1885 17887

Barely half a mile from the Minster, St Mary's was begun in the 12th century as a chapel to the Minster. When the nave was rebuilt in the 13th century, the walls were so weakened that the central tower finally collapsed in 1520, killing several worshippers.

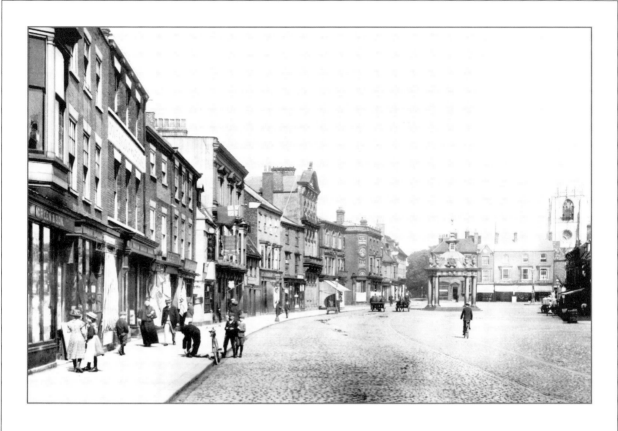

BEVERLEY
The Market Place 1900 45284
Little has changed in the Market Place between the
time of this photograph and the earlier
photograph, No 17885, taken in 1886. The road has
been surfaced with stone setts, and St. Mary's
Church looks on as ever.

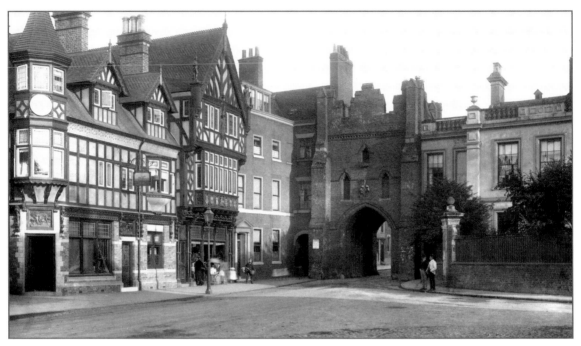

BEVERLEY, NORTH BAR 1894 34796
Beverley was protected from the pagan hordes - and many other later invaders - by a ditch and five drawbridges. The North Bar is the only one that survives; it was built in brick in the 15th century.

BEVERLEY, WESTWOOD ROAD 1900 45289
The main road out of Beverley shows the fine homes of the middle classes; each built with slightly differing features. Francis Frith probably took this picture soon after sunrise, as the blinds are still down and there is a total absence of residents.

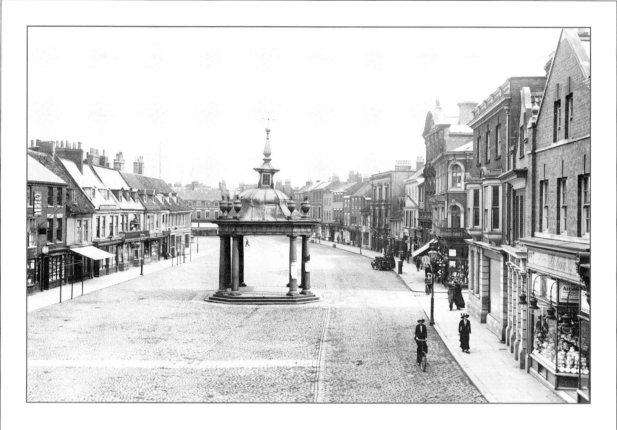

BEVERLEY

The Market Place 1913 65563

Here we have a closer view of the Market Cross, showing the vast amount of setts needed to cover the road. Streets such as this are often wrongly described as cobbled streets. In fact, cobbles are circular and very rare, whereas there are stone sett streets in most northern towns.

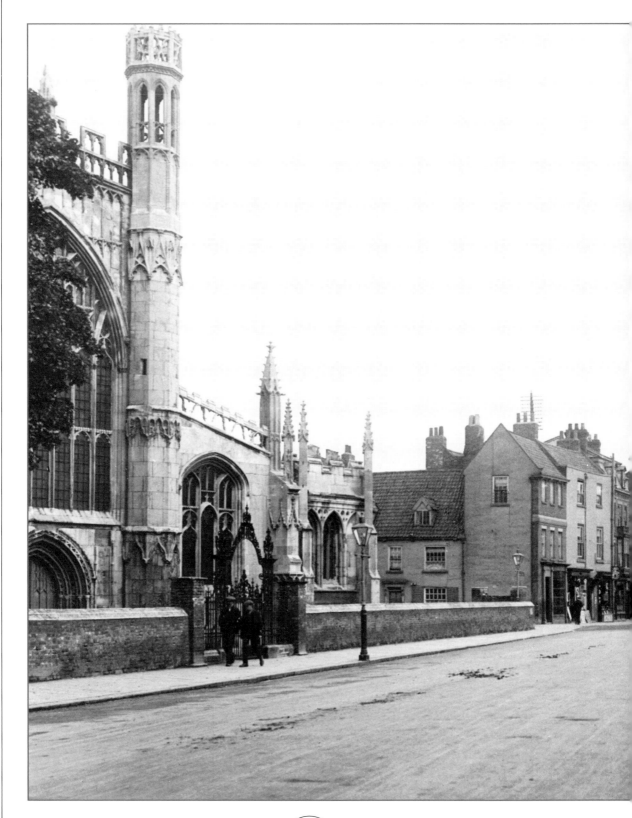

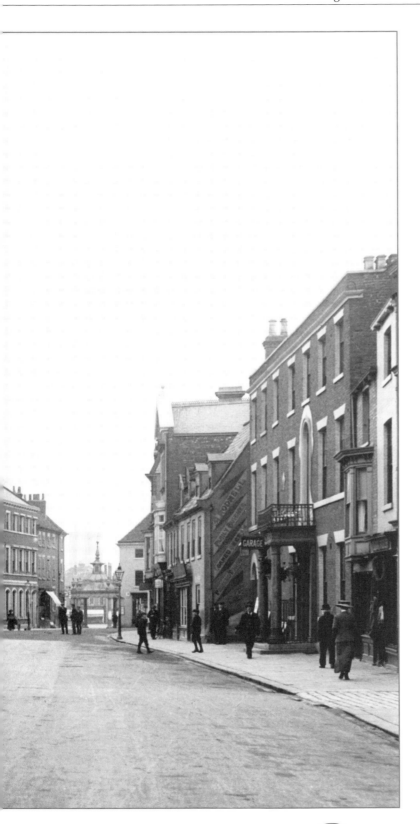

BEVERLEY
NORTH BAR WITHIN 1913 65566
This photograph shows the layout of Beverley well, with North Bar leading to the Market Place. It also reveals more detail of the west front of St Mary's Church.

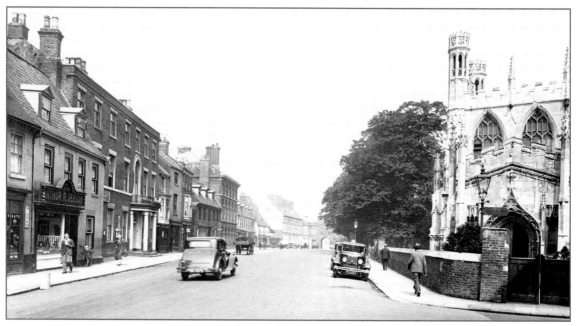

BEVERLEY, NORTH BAR 1934 86113
This is a mirror image of photograph No 65566. It looks towards the North Bar, and gives the best view of the perpendicular west towers of St Mary's Church. The only clue that time has moved on twenty years is the advent of the motor car.

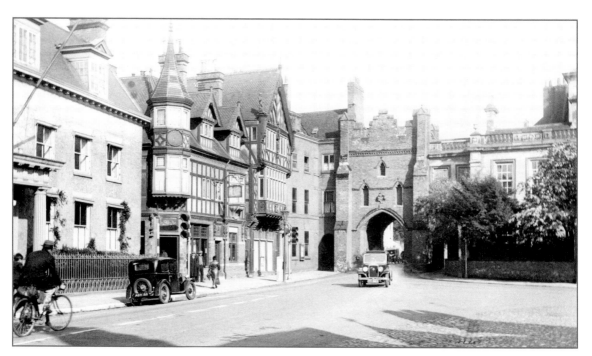

BEVERLEY, NORTH BAR 1934 86114
By this time cars were passing through the Bar. We are able to see part of the Guildhall (far right), which was built in the 17th century; a portico was added in 1832.

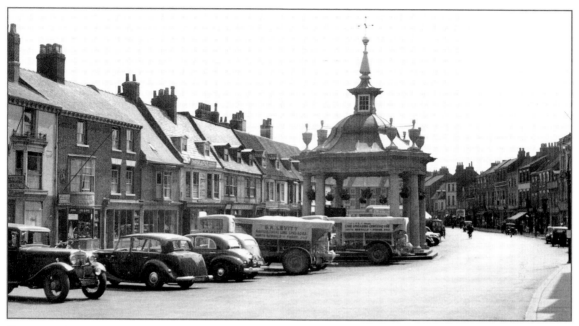

BEVERLEY, THE MARKET PLACE c1955 B80011

By the 1950s the Market Place had become a car park, except for the Saturday market. The two lorries parked closest to the Market Cross were preparing for work on the surrounding fields. As the sign-writing shows, they were the property of G H Levitt, Agricultural Lime Spreaders.

WALKINGTON, THE VILLAGE c1955 W318002

The Hayride, which takes place in Walkington on the third Sunday in June, probably has its origins in pagan superstition. A colourful procession of splendid Shire horses pull ancient corn wagons around the area, a tradition known nowhere else in Britain.

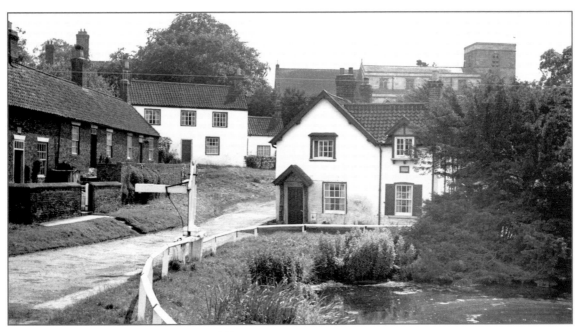

BISHOP BURTON, THE VILLAGE CORNER c1960 B427002
This unforgettable village cupped in a hollow with a large wayside pond is the home of All Saints' Church. In the chancel is a chalice brass to Vicar Johnson, 1460, one of the earliest examples of this kind of brass work. There is also a bust of John Wesley carved from an elm that grew on the green where he preached.

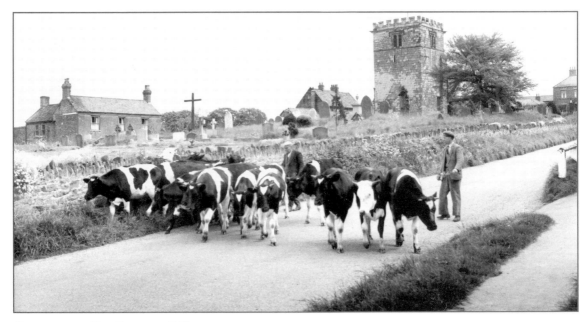

GOODMANHAM, THE CHURCH c1965 G156002
Allegedly, in AD 627 the high priest Coifi renounced his pagan beliefs and burnt his temple to the ground. This is now the site of the part-Norman church; like churches everywhere, it is difficult to date because of later additions and extensions. The chancel was re-built in the 13th century, and the tower was given its belfry and battlements in the 15th century.

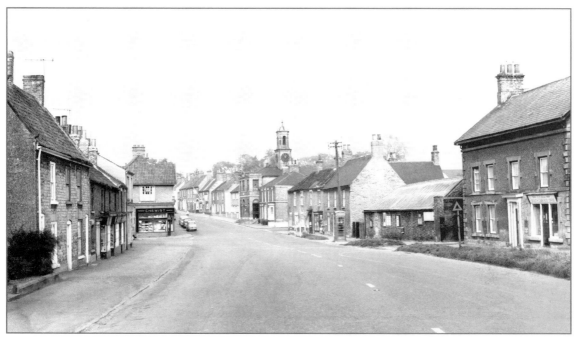

SOUTH CAVE, THE MARKET PLACE c1965 S403028

The main road winds its way through sleepy South Cave, passing the Town Hall in the centre. The good burghers of the village spared no expense in having the Bell Tower renovated in 1999, ready for the Millennium.

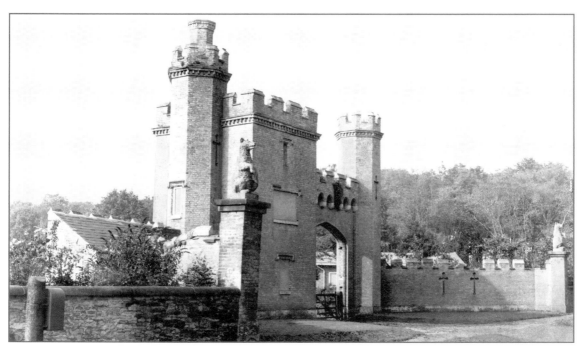

SOUTH CAVE, BEAR LODGE c1965 S403024

Bear Lodge, now a private house, is one of two lodge houses which led to Cave Castle - a folly built in the 19th century. It is now a hotel and country club.

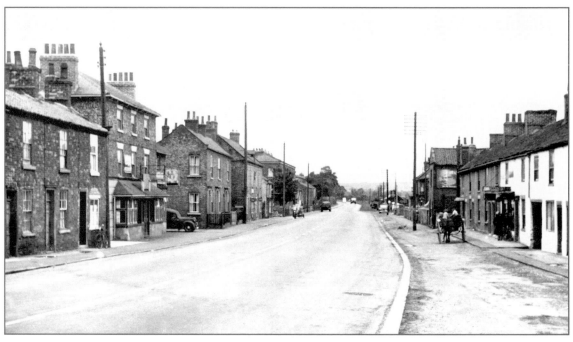

NEWPORT, MAIN STREET c1955 N221001
This is definitely the age of the car, so it is pleasing to see a pony and trap outside the shop, still holding on to a by-gone age.

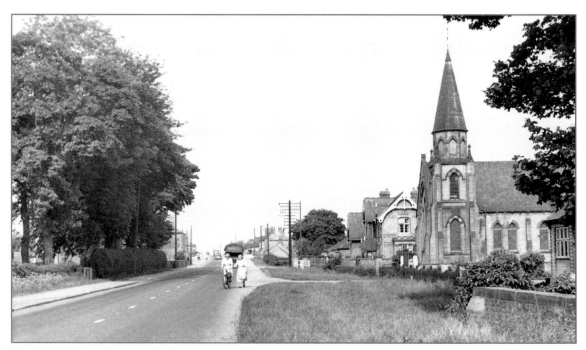

NEWPORT, THE VILLAGE c1955 N221011
This village was indeed a new port; it sits beside the Market Weighton Navigation and Canal, which drained the fens and marshland.

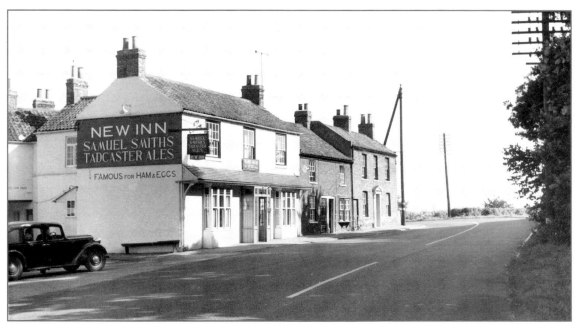

HOLME UPON SPALDING MOOR, NEW INN CORNER c1955 H270023
The pub dominating the picture is now called the Kingfisher in honour of the landlord, who was not called King but was a keen angler. The original owners bought a new-fangled dynamo in 1870; this was thus the first place in Holme to have electricity.

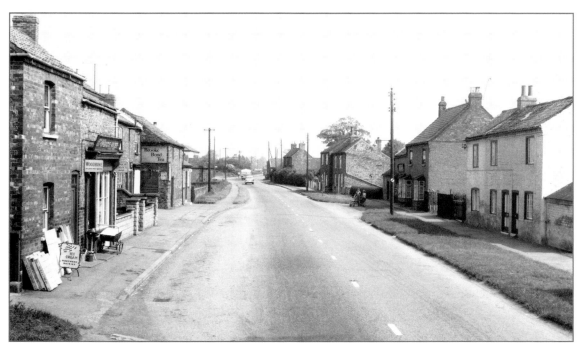

HOLME UPON SPALDING MOOR, MOOREND c1965 H270044
A memorable sight in the Vale of York is All Saints' Church crowning this island hill (the meaning of 'holme') in the flat former marshland. This photograph would have been taken from the churchyard.

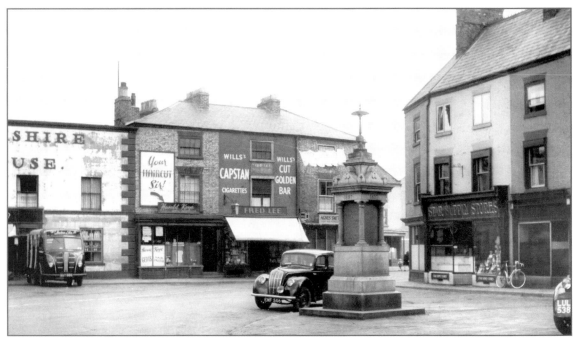

POCKLINGTON, THE MARKET PLACE c1955 P186002

Every town, village and hamlet had its market place; Pocklington market is still held on Tuesdays and Thursdays. It may not be cattle and corn today, but it still gives a feeling of community.

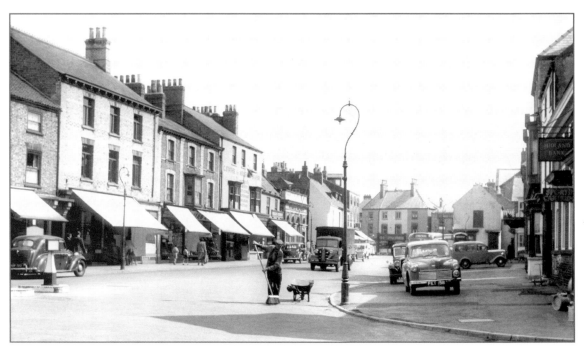

POCKLINGTON, THE MARKET PLACE c1955 P186001

Times have moved on, but the street sweeper is oblivious to the traffic around him. William Wilberforce, the abolitionist, went to the local grammar school, which was founded in 1514.

WARTER, THE VILLAGE POND c1960 W320007
High above the pond stands the church dedicated to St James. It was built in the 19th century in 14th-century style; its fine octagonal spire graces its western tower.

SUTTON UPON DERWENT, THE WEIR c1960 S407008
Between the weir and the disused flourmill can be seen the lock allowing passage along the Derwent. Sutton Mill, re-built in 1867, showed Victorian ingenuity by taking its power from the weir.

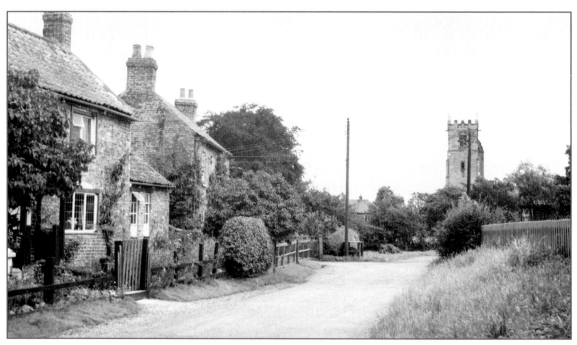

WILBERFOSS, MIDDLE STREET c1960 W322008
The parish church here is dedicated to St John the Baptist. Wilberfoss gave its name to the family who were direct antecedents of William Wilberforce.

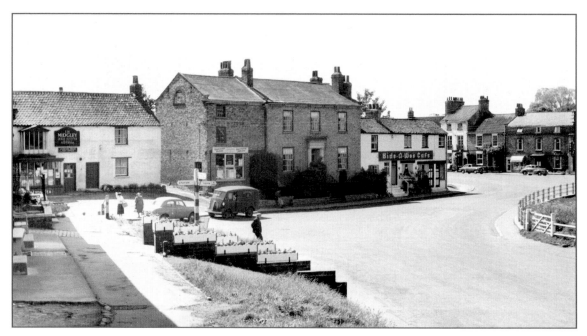

STAMFORD BRIDGE, THE POST OFFICE AND SQUARE c1960 S405010
Tourism seems to be taking over now. There is a stone marker on the weedy green, in the foreground. It is a reminder of a famous battle in 1066 when King Harold of England defeated Harald of Norway. It has always been over-shadowed by a more famous battle that took place north of Hastings.

STAMFORD BRIDGE
The Bridges c1960
The East and West bridges cross the
Derwent side by side. The narrow arched
bridge was built in 1727 and stands
above the battleground. The later bridge
now carries the railway.

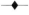

SLEDMERE
The Triton Inn and the Post Office c1960
The eccentric Tatton family, who owned
the land around here, are worthy of a
book to themselves, but space does not
permit. Triton is a corruption of Tatton.
It will come of little surprise that the
pub thrives, whilst the Post Office
is long gone.

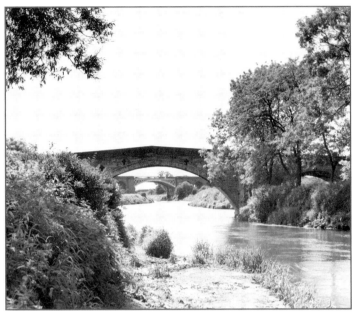

STAMFORD BRIDGE, THE BRIDGES c1960 S405006

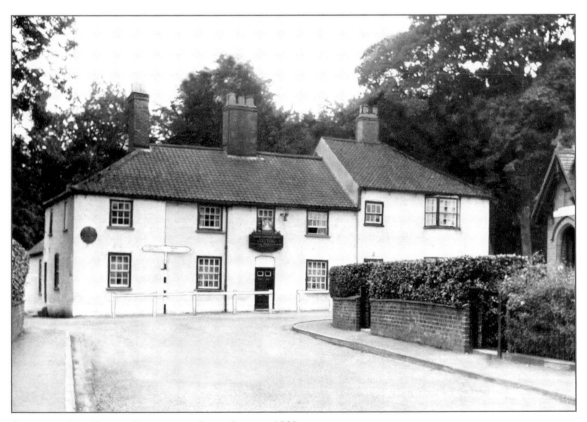

SLEDMERE, THE TRITON INN AND THE POST OFFICE c1960 S401012

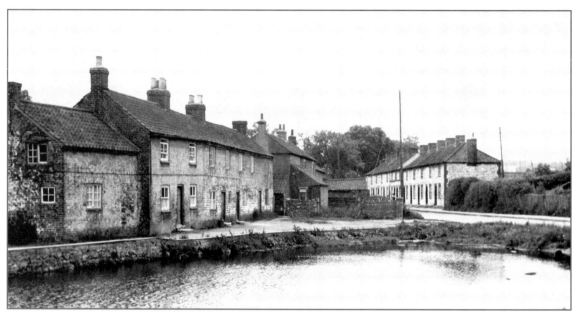

LANGTOFT, THE POND c1955 L229003

This village gained its name from one Peter de Langtoft, a French poet and chronicler. His best known work was a history of England up to the death of King Edward I. Written in rhyming French verse, it first appeared in translation as late as 1866. He died a Canon of Bridlington Priory in 1307. He is commemorated in the village by the Langtoft Cross on the village green.

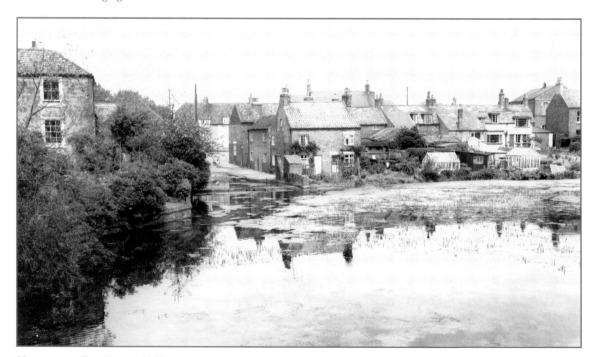

NAFFERTON, THE POND c1960 N989033

The mere is the focal point of the village. It was once a millpond, which supplied waterpower to several mills situated on its south-east bank. The last mills and maltings were demolished in 1985, and the land was redeveloped for housing.

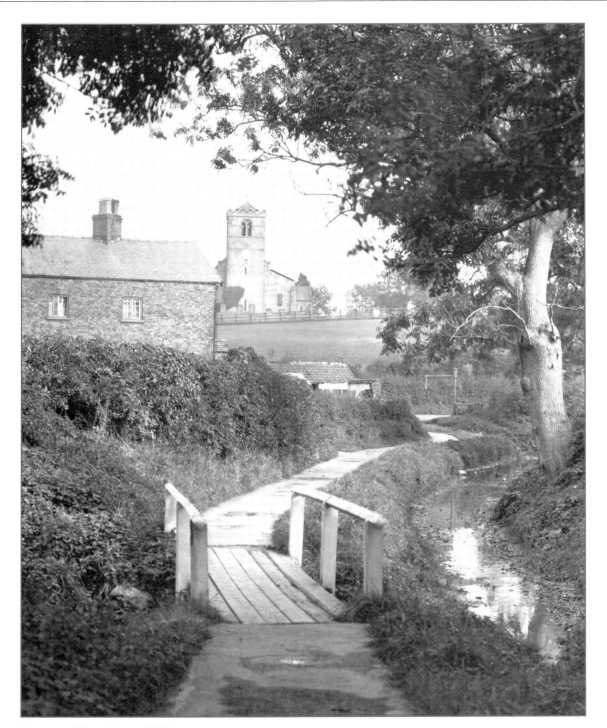

RUDSTON, WATER LANE c1950 R277001
The path and stream present an idyllic amble, which has a darker side up the hill in All Saints' graveyard. An uncanny stone monolith stands there; it is over 25 feet high and six feet wide. The nearest stone quarry is forty miles away, so a lot of manpower (or glacial action) was needed to move it this far. Doubtless it pre-dates the church, and is a monument to pagan gods.

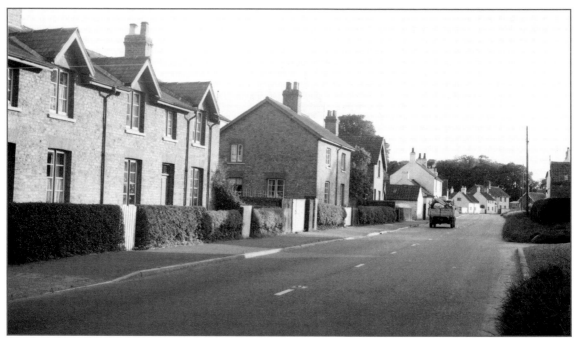

BURTON AGNES, MAIN STREET c1955 B254006
The A166, which passes through the village, narrows slightly, dips and turns as it meanders its way through. In the dip is the village pond, which attracts children both young and old to feed the many ducks who have made it their home.

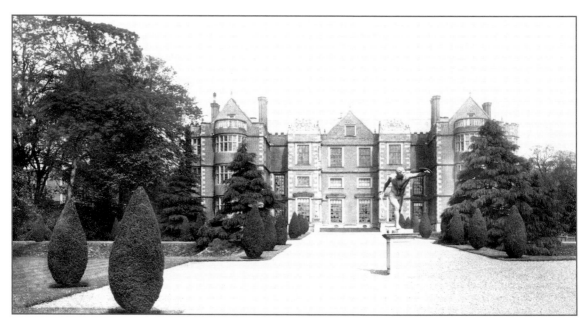

BURTON AGNES, THE HALL c1885 18021
This beautiful Elizabethan house is four hundred years old, and is still owned by the ancestors of Sir Henry Griffith, who designed and built it. The Hall contains superb carvings and plaster work, as well as a fine alabaster and a large collection of English and French paintings. The Hall is surrounded by beautiful gardens with a maze and many rare and exotic plants, specially imported.

BURTON AGNES
The Hall Gateway c1885
The village church, St Martin's, of late Norman to Perpendicular vintage, is found through the gateway and contains family tombs.

BRIGHAM
The Village c1960
The flatness of the Wolds is interrupted by the hill on which the tiny hamlet of Brigham sits. The minor road off the B1249 rises with dwellings on either side, peaks and falls again to an old wooden bridge with rusted iron railings that crosses brackish water which eventually falls into the River Hull.

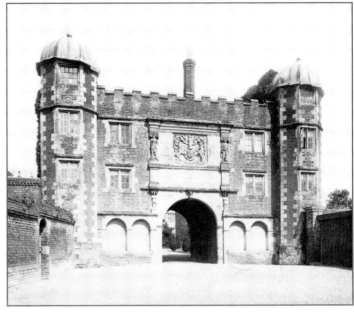

BURTON AGNES, THE HALL GATEWAY C1885 18025

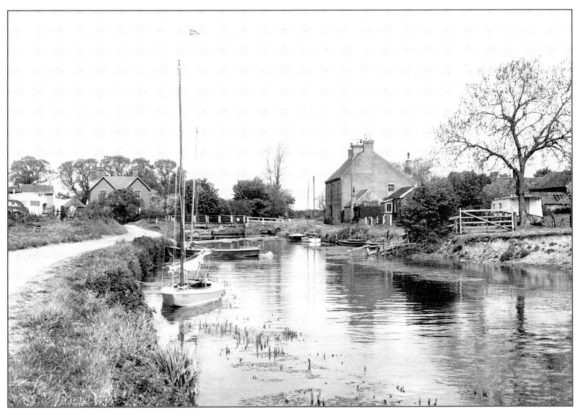

BRIGHAM, THE VILLAGE C1960 B854002

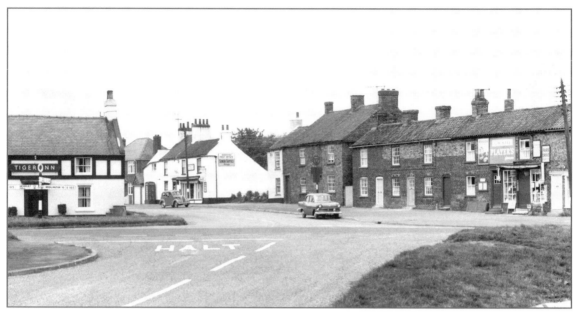

BEEFORD, THE CROSS-ROADS c1960 B664002
Situated around the cross-roads where the A165 bisects the B1249, Beeford is a long, spread-out village with estates and houses branching off the two main streets. The village does not have so many shops as it once did, but there is still the Post Office, a butcher and a large surgery serving the surrounding area. There are two public houses, the Tiger and the Yorkshire Rose. Neither claim to have ghosts.

FRODINGHAM, THE VILLAGE 1904 52167
This picture shows a rarity for the Yorkshire Wolds - a thatched cottage. There are plenty in the southern, milder counties of Devon, Somerset and Wiltshire, but very few in the wilder Cornwall or the windswept north. It looks recently re-thatched, and work is obviously continuing on the gable end. It looks structurally sound but in need of a good coat of whitewash.

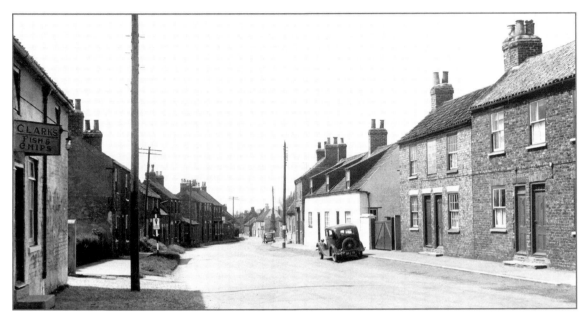

NORTH FRODINGHAM, HIGH STREET c1955 N103006

The B1249 road passes through the High Street, sometimes known as Main Street, where it is lined with houses, farms, cottages and farm buildings, plus the village shop and the obligatory pubs, the Blue Post and the Star. Outside the village school can be found the War Memorial, with the inscription 'Greater love hath no man than this, that a man lay down his life for his friends' (St John, Chapter 15, Verse 13).

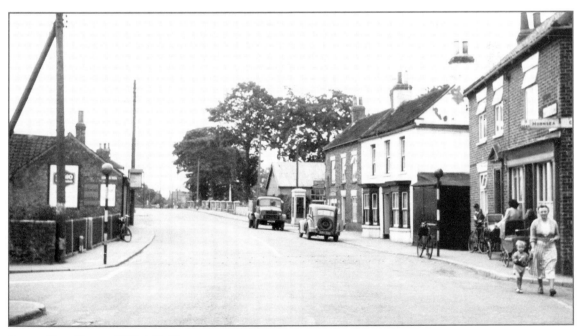

LEVEN, MAIN ROAD c1955 L375008

The site of the village has moved several times over the centuries, and the name means 'smooth' or 'level'. In 1735 it was, presumably, a more picturesque spot than shown here, as it was then called 'Rosedale in Leven'. The white telephone box is another give-away that it was in the Hull telephone area.

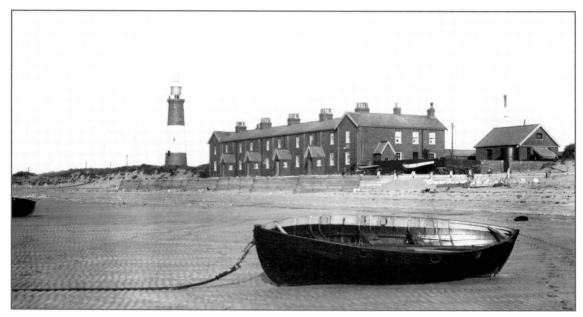

SPURN HEAD, THE LIGHTHOUSE 1899 44754

One of the most striking features of Spurn is the black and white lighthouse. The one pictured here would be quite new at the time of the photograph; it was erected in 1895. It is now just an empty shell: it was closed down, and the light went out, at dawn on 31 October 1986. The only light on Spurn today is a flashing green starboard light on the very tip of the point.

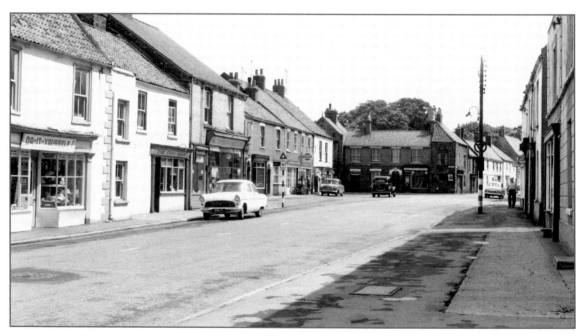

PATRINGTON, THE MARKET PLACE c1960 P184020

The gleaming white Ford Consul outside the Hull Co-operative Society belies the history to be found here. The 'Queen of Holderness' (The 'King' is at Hedon) is St Patrick's Church, an incomparable parish church. Like a cathedral in miniature, it is utterly beautiful in a pale, serene way, a masterpiece of the Decorated period.

EASINGTON, THE SEASIDE ROAD c1955 E114502
This village sits right on the coast of the North Sea some five miles north of Spurn Point (or Head). The road here logically runs down to the sea from the church of All Saints, which is a very ancient and small Gothic structure.

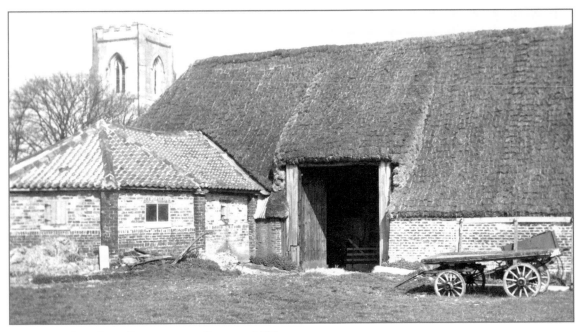

EASINGTON, THE TITHE BARN AND THE CHURCH c1955 E114504

As with most rural churches, All Saints' had an attached farm and barn. The name 'tithe' indicates that it was built with a tax or contribution of a tenth part of one's income for the support of a religious establishment. 'Tithe' or 'tenth' derives from the Old English word 'teogotha'.

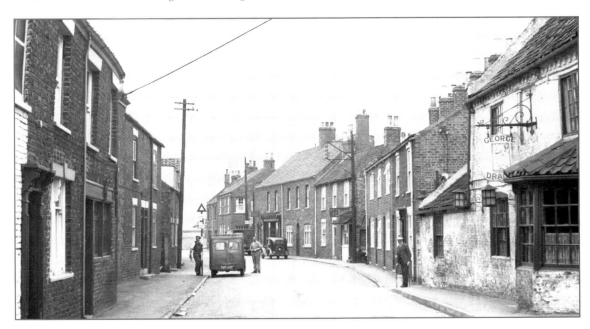

ALDBROUGH, HORNSEA ROAD c1955 A316013

The village is situated twelve miles north of Hull in the Vale of Holderness. The parish covers an area of some 5,500 acres, whilst the village has a thriving population of 1,200. The main road through the village is Hornsea Road, where the George and Dragon public house is situated. The original pub was built in the 17th century as a coaching inn, whereas the present one was entirely re-built in the 19th century.

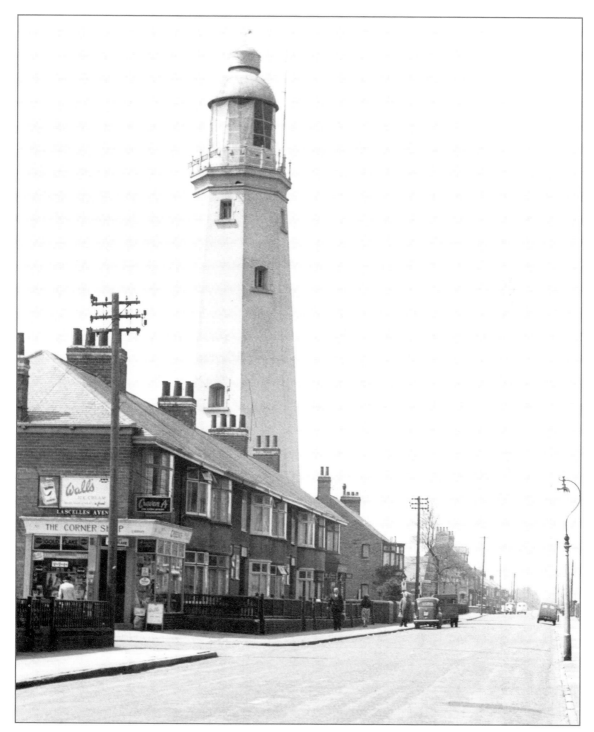

WITHERNSEA, THE LIGHTHOUSE 1955 W177010
The village developed into a holiday resort after the opening of the railway line from nearby Hull. Towering above the skyline is the lighthouse, which is now a museum partly dedicated to Withernsea's most famous daughter, the actress Kay Kendall.

HORNSEA, THE MERE c1955 H272100

This is the largest freshwater lake in Yorkshire, covering 467 acres; it is two miles long and one mile wide. It was created by glacial erosion in the last Ice Age, some 10,000 years ago. Home to herons, grebes, cormorants and teal, it is wildlife wonderland; no wonder that it is protected by the RSPB.

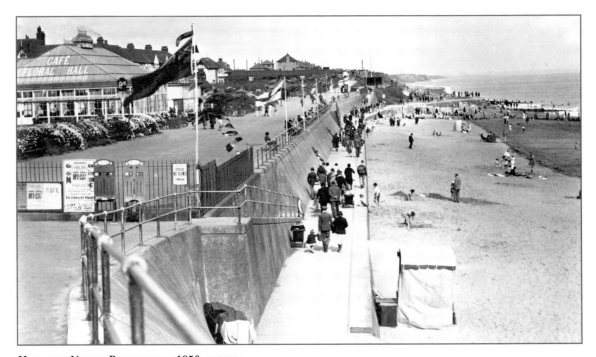

HORNSEA, NORTH PROMENADE c1950 H272084

The old village has extended itself to the sea, where there are boarding houses, safe sandy beaches and the Floral Hall, where a string quartet accompanied your pot of tea and sandwiches.

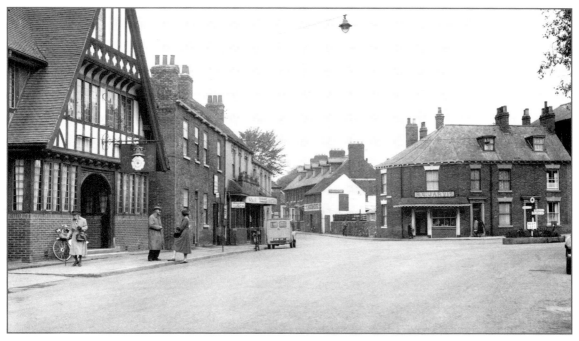

HORNSEA, THE MARKET PLACE c1955 H272114

Also known as the Bull Ring, the Market Place is, and always has been, the centre of village life. The Town Hall houses a small museum of Roman and Anglo-Saxon relics, which provide further testimony to the antiquity of this area.

HORNSEA, SEATON ROAD c1950 H272078

The greenery and climbing plants, the clematis and the ivy, adhering to the houses verify that Seaton Road is a most pleasant lane on the way to Seaton. But it is the pottery, founded by two brothers, Colin and Desmond Rawson, in 1949, for which Hornsea is world-renowned. The first items were produced from a sea-front cottage, but later demand necessitated a larger site, which now incorporates a leisure and retail park.

ATWICK, HORNSEA ROAD c1960 A172011

The village circles round the Green, which is graced by seasonal flowers, a delight even if you are just passing through on the seasonally busy B1242 road. One side of the road has the Post Office and village shop, whilst on the other is the Black Horse public house. On the green in front of the village hall an ancient stone cross raised on three steps stands nobly above the road.

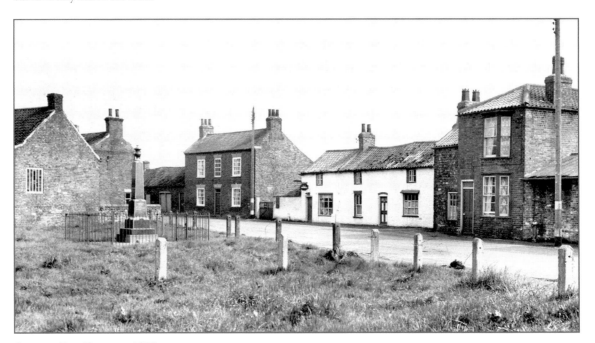

SKIPSEA, THE VILLAGE c1955 S399001

The village store faces the war memorial on the green, which appears to have been fenced off. Surely this was not protection from vandals! These people had been the scourge of Skipsea Castle in earlier times, so much so that Henry III had to demolish the castle in 1220.

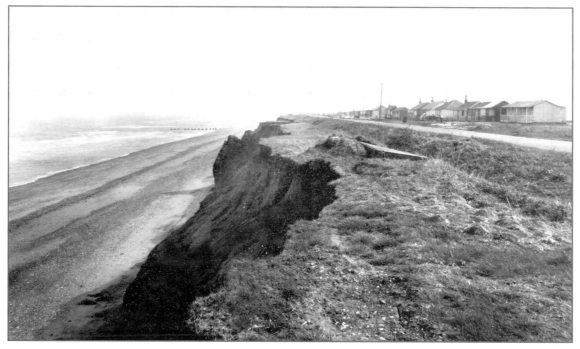

SKIPSEA, CLIFF ROAD c1955 S399012

SKIPSEA
Cliff Road c1955

When the Ice retreated after the last Ice Age, deposits of boulder clay were deposited along the east coast. With no hard bedrock, this area is suffering from coastal erosion which is measurable in metres per year. It is a major ecological problem, and one that can only be solved by literally dumping thousands of tons of rock on to the beach.

ULROME
The Church c1960

St Andrew's Church is framed beautifully between the trees; but since this picture was taken, housing development has encroached on the surrounding fields. The Old School House is now a private dwelling, as is The Old Joiners Shop.

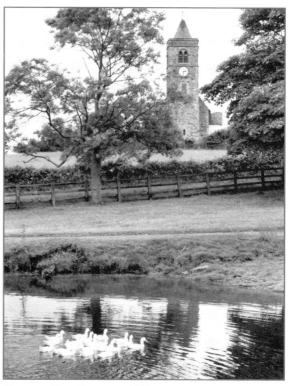

ULROME, THE CHURCH c1960 U34050

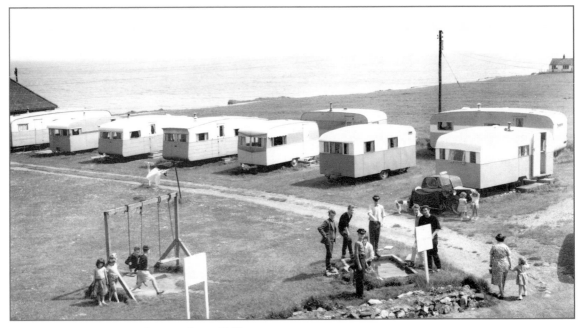

ULROME, THE BEACHBANK CARAVAN SITE c1960 U34074

The village itself has a rural feel to it, but it is less than a mile from the beach and the North Sea. There are plenty of camping and caravan sites to cater for the holidaymakers. In this scene the two little girls and dog are taking an interest in the BSA motor cycle and sidecar.

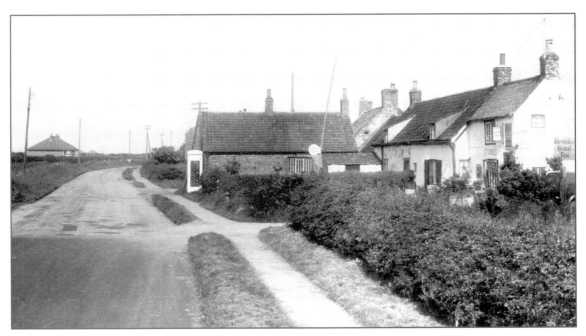

BARMSTON, MAIN STREET c1965 B850022

This is another popular holiday retreat. It is to be found on the rough road that leads off the main A165. Along with the village amenities, there is a Post Office, a village store and a lively pub called the Black Bull. Once again, the white telephone box shows that this is within the private Hull Exchange.

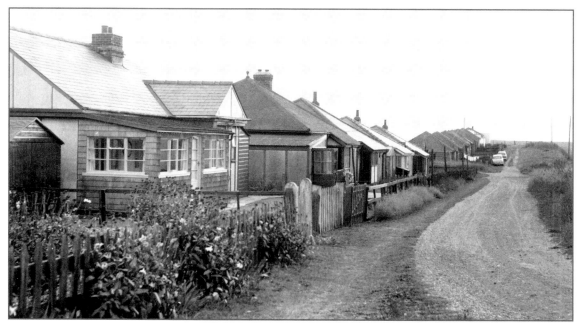

BARMSTON, THE BUNGALOWS c1965 B850004

There are good views both north and south along the coastline, and on a clear day one can see for miles in both directions and out to sea. Once more, coastal erosion is the big problem: it is believed that the sea has claimed two and a half miles of land since Roman times.

CARNABY, VILLAGE SCENE c1885 18016

Just two and a half miles from Bridlington lies the tiny group of houses which make up the parish of Carnaby, where the church is dedicated to St John the Baptist. Spring or autumn would seem the likely time of year for this photograph, judging by the leafless trees which grow either side of the central holm oak, an evergreen with foliage resembling holly.

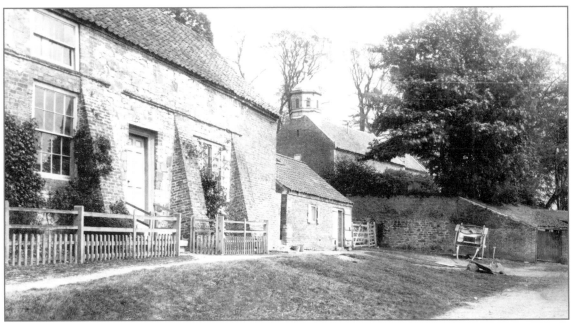

BESSINGBY, THE CHURCH 1886 18017

This parish, just one mile up the road from Carnaby, contains not much more than the church, which is dedicated to St Magnus. The recent stone-built structures along the front of the house are no mere decoration, but are there to strengthen the fabric of the much older house.

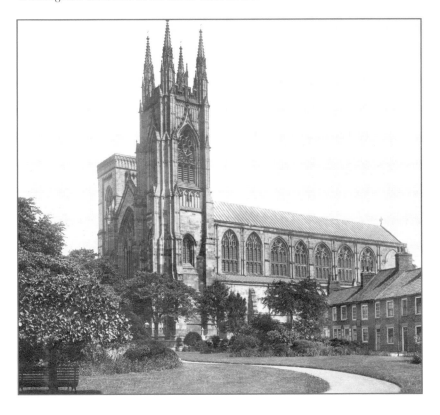

BRIDLINGTON PRIORY CHURCH AND BAYLE GATE 1923 74295
One mile inland is the church of St Mary, which includes the nave of the Augustinian priory founded here in 1119 by Walter de Gant. It was saved from destruction at the Dissolution as it was already in use as a parish church. The Bayle Gate across the green, built in 1388, was at various times a courtroom, barracks, a prison and finally a school.

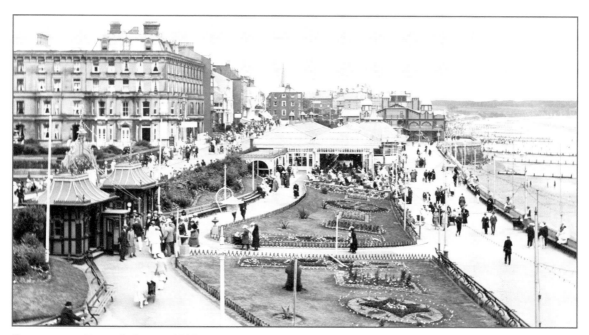

BRIDLINGTON, PRINCE'S PARADE 1923 74279

This used to be the most genteel of the Yorkshire seaside resorts, a view that is exemplified by the promenading of the nouveau riche in this 1920s photograph. It would be some decades before the railway brought the West Yorkshire working classes.

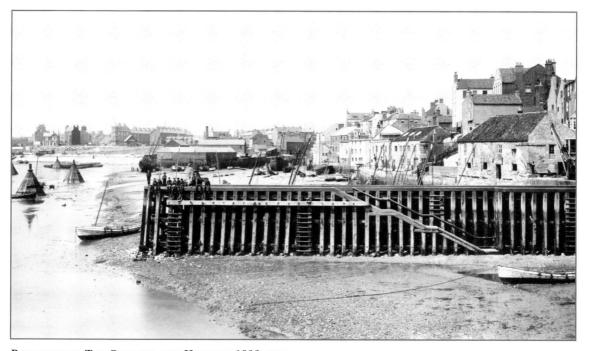

BRIDLINGTON, THE QUAY AND THE HARBOUR 1886 18041

A small fishing fleet sailed from here deep into Icelandic waters, long before any fishing disputes. Stones from the old priory were used to build the two harbour piers, and also the fishermen's cottages that cluster near the waterside.

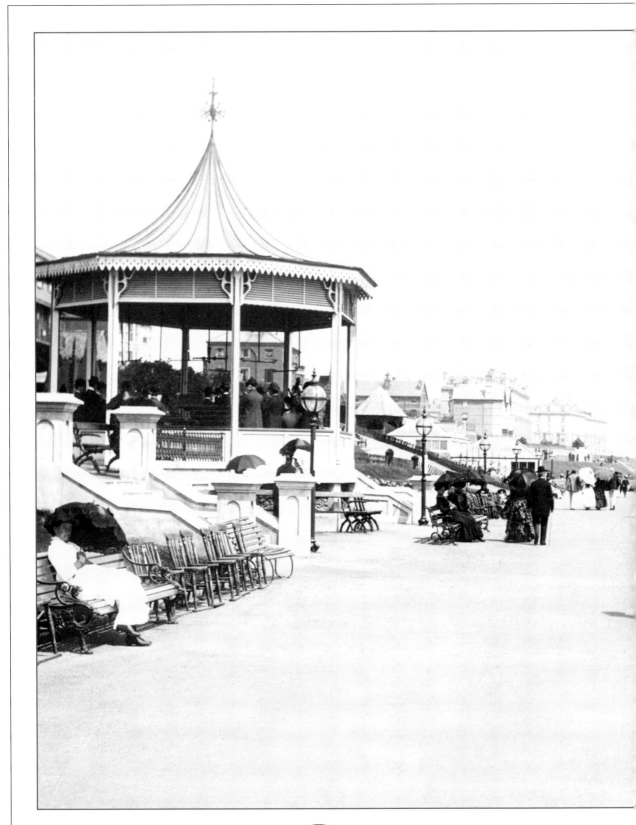

BRIDLINGTON, THE ESPLANADE BANDSTAND 1886 18224
Protected on the north-east by the great headland of Flamborough, there are long stretches of fine sand both north and south of the harbour. Away from the cold winds, the Victorian gentry were able to pursue their favourite pastime - a gentle stroll.

SEWERBY, MAIN STREET C1960 S396007

The village of Sewerby is pleasantly situated on the coast of Bridlington Bay, about one mile from Flamborough station on the North-Eastern Railway. It is a place of considerable antiquity: it was mentioned in the Domesday Book, where it was known as 'Siwardbi'. The 'bi' indicates its Danish origins; it means simply the 'place' or 'abode' of Siward.

MARTON, THE HALL C1885 18020

Built in 1672 by Gregory Creake, Marton Hall was a brick building two storeys high with five bays, panelled rooms and a carved wooden staircase. Alterations took place in the 18th and 19th centuries, and in 1912 it became a boarding school, which has since closed.

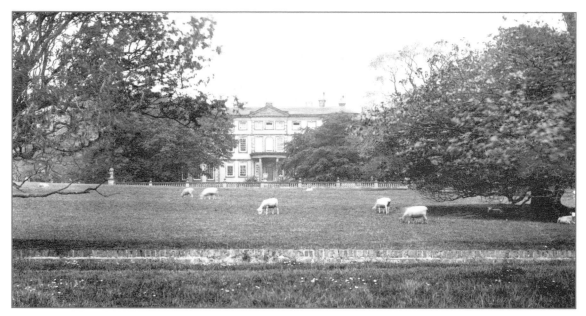

SEWERBY, THE HALL c1885 18019

The Hall was built in the early 18th century, when the parkland was laid out; it includes the oldest monkey-puzzle trees in the world. The house and grounds were bought by Bridlington Council in 1934 and opened to the public by Amy Johnson. After her death on one of her long-distance flights, her father gave her memorabilia to the Hall, and the Amy Johnson room was opened in 1956.

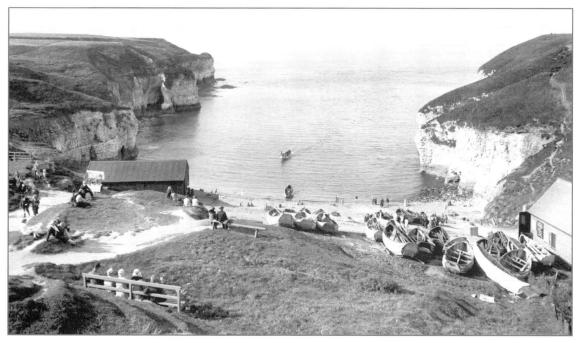

FLAMBOROUGH HEAD, THE NORTH LANDING 1927 80139

A mix of holiday makers and fishermen gather round the rarely calm sea, though the cobles and other fishing boats are pulled well inland - just in case. The lifeboat station can partially be seen to the extreme right of the picture.

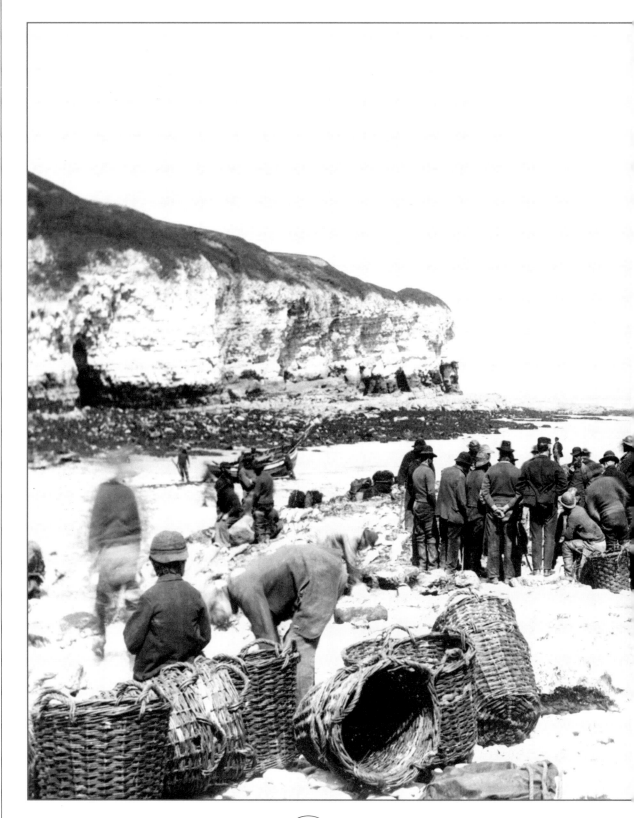

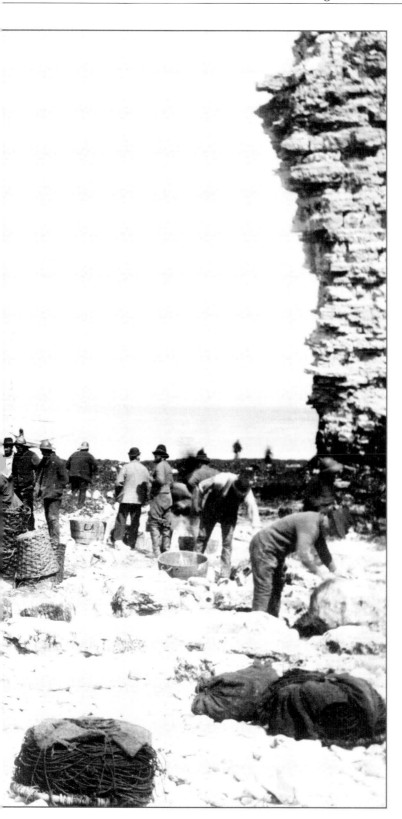

FLAMBOROUGH HEAD
THE NORTH LANDING 1886 18001
The chalky white cliffs of Flamborough
Head jut out of the Yorkshire coast
where the Wolds plunge into the sea.
The promontory forms the nose of the
bearded profile of the Yorkshire map.
Here at the north landing the cobles
are hauled up the beach and crab pots
unloaded.

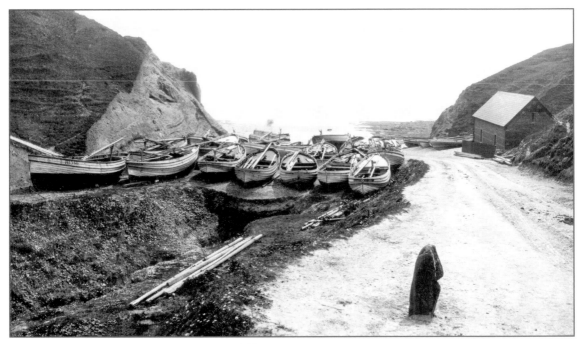

FLAMBOROUGH HEAD, THE SOUTH LANDING c1885 18009
Ships have foundered here for centuries; in 1779, locals watched as John Paul Jones won a sea battle with two English men-of-war. The area was taken by the Vikings a thousand years ago, and is still sometimes called Little Denmark.

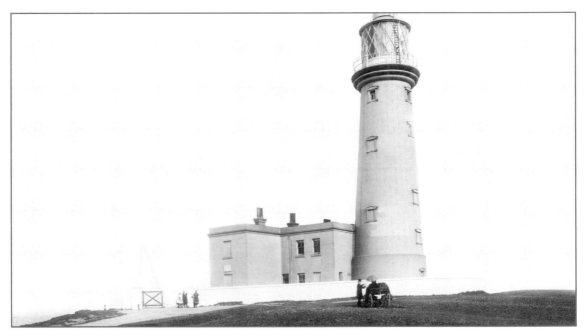

FLAMBOROUGH, THE LIGHTHOUSE 1897 39352
The name of this place is probably derived from the 'flame' or light, which was placed on the head to direct mariners in the navigation of these treacherous waters. The first lighthouse was erected on 1 December 1806, and the revolving light, which has ever since flamed by night from the Head, burst forth for the first time.

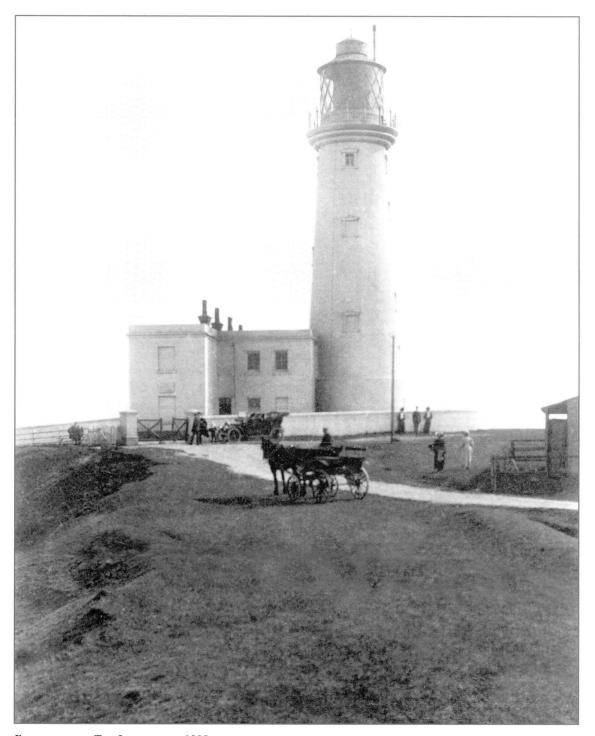

FLAMBOROUGH, THE LIGHTHOUSE 1908 59914
According to Coates' descriptive poem, 'From June, 1770, to the end of the year 1806, not fewer than 174 ships were wrecked or lost on Flamborough Head and its environs, but since the erection of the lights, to March 1913, not one vessel had been lost'.

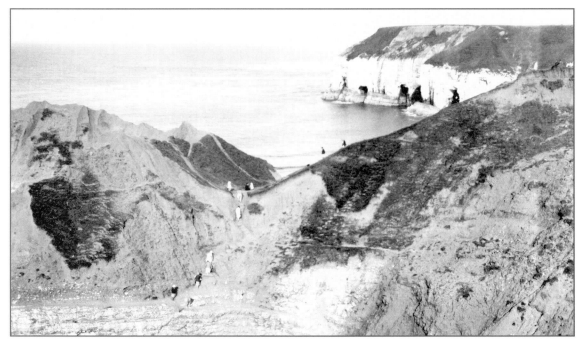

THORNWICK BAY c1950 T169002

The wind- and wave-sculptured cliffs, 300 to 400 feet high here, are really a continuation of Flamborough Head. They are the best and largest breeding ground for sea birds in England, with numbers at their peak in the first half of July.

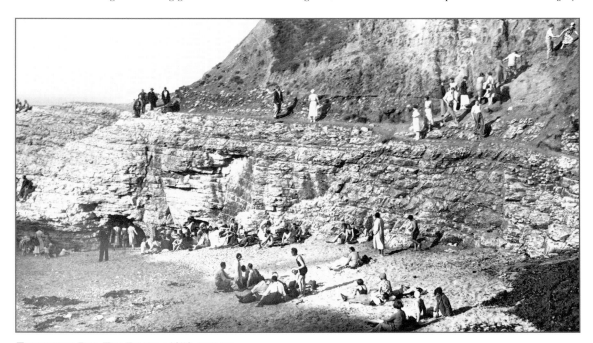

THORNWICK BAY, THE ROCKS c1950 T169008

The only mainland colony of gannets is increasing, and so are the numbers of kittiwakes, guillemots, razorbills and puffins. Here at the Rocks was a favourite place for the 'climmers' or climbers to risk their necks to plunder the nests to sell eggs to the spectators. This trade was stopped by Act of Parliament in 1954 - for the safety of all.

BEMPTON
The Cliffs 1908
Just north of Flamborough is the
Bempton Cliffs RSPB reserve. It consists
of a narrow strip of clifftop grassland
and the magnificent chalk cliffs
themselves. These are the highest chalk
cliffs in the country, dropping 400
feet into the sea.

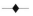

BEMPTON
Silex Bay 1908
In addition to the thousands of birds, as
at Thornwick, the cliffs and bay are of
international importance because of the
colony of over a thousand pairs of
gannets. There are also fifteen 'new'
species of butterfly, twelve recorded
types of bee and two new day-flying
moths - the Narrow-Bordered Burnet
and the Chimney Sweeper.

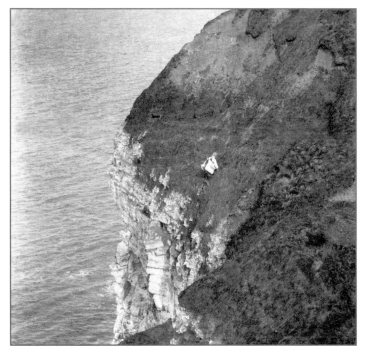

BEMPTON, THE CLIFFS 1908 59915

BEMPTON, SILEX BAY 1908 59913

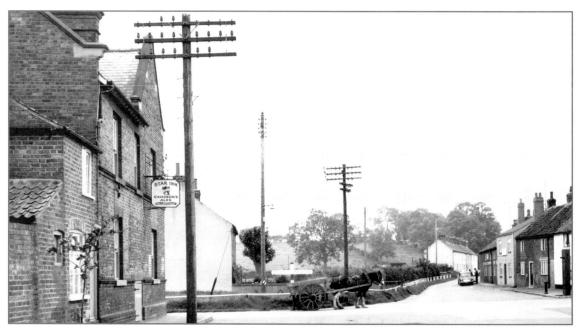

BURTON FLEMING, THE VILLAGE c1965 B433006
The village is in the valley of the Gypsey Race spring to the north of the Wolds. The cross-roads shown here are in the centre of the village. On one side is the butcher's shop and 'Black Jack', a cast iron water pump, which sad to say is no longer used. On the other side is the Burton Arms public house, which is still open.

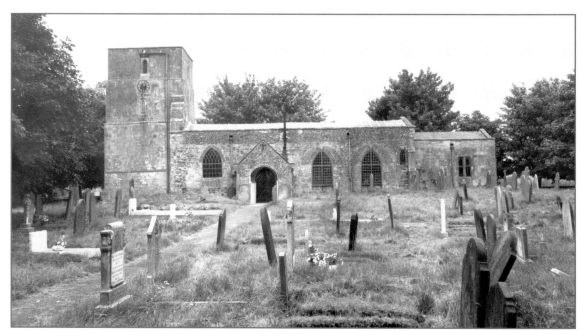

BURTON FLEMING, THE CHURCH c1950 B433003
The church of St. Cuthbert is of Early English origins, but was restored in 1877 and partially rebuilt in brick. There was once a south aisle, but this was removed, as was the chancel arch. A small turret clock, with two dials, was erected in the tower in commemoration of Queen Victoria's jubilee.

Index

Frith Book Co Titles

www.francisfrith.co.uk

The Frith Book Company publishes over 100 new titles each year. A selection of those currently available are listed below. For latest catalogue please contact Frith Book Co.

Town Books 96 pages, approx 100 photos. County and Themed Books 128 pages, approx 150 photos (unless specified). All titles hardback laminated case and jacket except those indicated pb (paperback)

Title	ISBN	Price
Amersham, Chesham & Rickmansworth (pb)	1-85937-340-2	£9.99
Ancient Monuments & Stone Circles	1-85937-143-4	£17.99
Aylesbury (pb)	1-85937-227-9	£9.99
Bakewell	1-85937-113-2	£12.99
Barnstaple (pb)	1-85937-300-3	£9.99
Bath (pb)	1-85937419-0	£9.99
Bedford (pb)	1-85937-205-8	£9.99
Berkshire (pb)	1-85937-191-4	£9.99
Berkshire Churches	1-85937-170-1	£17.99
Blackpool (pb)	1-85937-382-8	£9.99
Bognor Regis (pb)	1-85937-431-x	£9.99
Bournemouth	1-85937-067-5	£12.99
Bradford (pb)	1-85937-204-x	£9.99
Brighton & Hove(pb)	1-85937-192-2	£8.99
Bristol (pb)	1-85937-264-3	£9.99
British Life A Century Ago (pb)	1-85937-213-9	£9.99
Buckinghamshire (pb)	1-85937-200-7	£9.99
Camberley (pb)	1-85937-222-8	£9.99
Cambridge (pb)	1-85937-422-0	£9.99
Cambridgeshire (pb)	1-85937-420-4	£9.99
Canals & Waterways (pb)	1-85937-291-0	£9.99
Canterbury Cathedral (pb)	1-85937-179-5	£9.99
Cardiff (pb)	1-85937-093-4	£9.99
Carmarthenshire	1-85937-216-3	£14.99
Chelmsford (pb)	1-85937-310-0	£9.99
Cheltenham (pb)	1-85937-095-0	£9.99
Cheshire (pb)	1-85937-271-6	£9.99
Chester	1-85937-090-x	£12.99
Chesterfield	1-85937-378-x	£9.99
Chichester (pb)	1-85937-228-7	£9.99
Colchester (pb)	1-85937-188-4	£8.99
Cornish Coast	1-85937-163-9	£14.99
Cornwall (pb)	1-85937-229-5	£9.99
Cornwall Living Memories	1-85937-248-1	£14.99
Cotswolds (pb)	1-85937-230-9	£9.99
Cotswolds Living Memories	1-85937-255-4	£14.99
County Durham	1-85937-123-x	£14.99
Croydon Living Memories	1-85937-162-0	£9.99
Cumbria	1-85937-101-9	£14.99
Dartmoor	1-85937-145-0	£14.99
Derby (pb)	1-85937-367-4	£9.99
Derbyshire (pb)	1-85937-196-5	£9.99
Devon (pb)	1-85937-297-x	£9.99
Dorset (pb)	1-85937-269-4	£9.99
Dorset Churches	1-85937-172-8	£17.99
Dorset Coast (pb)	1-85937-299-6	£9.99
Dorset Living Memories	1-85937-210-4	£14.99
Down the Severn	1-85937-118-3	£14.99
Down the Thames (pb)	1-85937-278-3	£9.99
Down the Trent	1-85937-311-9	£14.99
Dublin (pb)	1-85937-231-7	£9.99
East Anglia (pb)	1-85937-265-1	£9.99
East London	1-85937-080-2	£14.99
East Sussex	1-85937-130-2	£14.99
Eastbourne	1-85937-061-6	£12.99
Edinburgh (pb)	1-85937-193-0	£8.99
England in the 1880s	1-85937-331-3	£17.99
English Castles (pb)	1-85937-434-4	£9.99
English Country Houses	1-85937-161-2	£17.99
Essex (pb)	1-85937-270-8	£9.99
Exeter	1-85937-126-4	£12.99
Exmoor	1-85937-132-9	£14.99
Falmouth	1-85937-066-7	£12.99
Folkestone (pb)	1-85937-124-8	£9.99
Glasgow (pb)	1-85937-190-6	£9.99
Gloucestershire	1-85937-102-7	£14.99
Great Yarmouth (pb)	1-85937-426-3	£9.99
Greater Manchester (pb)	1-85937-266-x	£9.99
Guildford (pb)	1-85937-410-7	£9.99
Hampshire (pb)	1-85937-279-1	£9.99
Hampshire Churches (pb)	1-85937-207-4	£9.99
Harrogate	1-85937-423-9	£9.99
Hastings & Bexhill (pb)	1-85937-131-0	£9.99
Heart of Lancashire (pb)	1-85937-197-3	£9.99
Helston (pb)	1-85937-214-7	£9.99
Hereford (pb)	1-85937-175-2	£9.99
Herefordshire	1-85937-174-4	£14.99
Hertfordshire (pb)	1-85937-247-3	£9.99
Horsham (pb)	1-85937-432-8	£9.99
Humberside	1-85937-215-5	£14.99
Hythe, Romney Marsh & Ashford	1-85937-256-2	£9.99

Available from your local bookshop or from the publisher

Frith Book Co Titles (continued)

Ipswich (pb)	1-85937-424-7	£9.99	St Ives (pb)	1-85937415-8	£9.99
Ireland (pb)	1-85937-181-7	£9.99	Scotland (pb)	1-85937-182-5	£9.99
Isle of Man (pb)	1-85937-268-6	£9.99	Scottish Castles (pb)	1-85937-323-2	£9.99
Isles of Scilly	1-85937-136-1	£14.99	Sevenoaks & Tunbridge	1-85937-057-8	£12.99
Isle of Wight (pb)	1-85937-429-8	£9.99	Sheffield, South Yorks (pb)	1-85937-267-8	£9.99
Isle of Wight Living Memories	1-85937-304-6	£14.99	Shrewsbury (pb)	1-85937-325-9	£9.99
Kent (pb)	1-85937-189-2	£9.99	Shropshire (pb)	1-85937-326-7	£9.99
Kent Living Memories	1-85937-125-6	£14.99	Somerset	1-85937-153-1	£14.99
Lake District (pb)	1-85937-275-9	£9.99	South Devon Coast	1-85937-107-8	£14.99
Lancaster, Morecambe & Heysham (pb)	1-85937-233-3	£9.99	South Devon Living Memories	1-85937-168-x	£14.99
Leeds (pb)	1-85937-202-3	£9.99	South Hams	1-85937-220-1	£14.99
Leicester	1-85937-073-x	£12.99	Southampton (pb)	1-85937-427-1	£9.99
Leicestershire (pb)	1-85937-185-x	£9.99	Southport (pb)	1-85937-425-5	£9.99
Lincolnshire (pb)	1-85937-433-6	£9.99	Staffordshire	1-85937-047-0	£12.99
Liverpool & Merseyside (pb)	1-85937-234-1	£9.99	Stratford upon Avon	1-85937-098-5	£12.99
London (pb)	1-85937-183-3	£9.99	Suffolk (pb)	1-85937-221-x	£9.99
Ludlow (pb)	1-85937-176-0	£9.99	Suffolk Coast	1-85937-259-7	£14.99
Luton (pb)	1-85937-235-x	£9.99	Surrey (pb)	1-85937-240-6	£9.99
Maidstone	1-85937-056-x	£14.99	Sussex (pb)	1-85937-184-1	£9.99
Manchester (pb)	1-85937-198-1	£9.99	Swansea (pb)	1-85937-167-1	£9.99
Middlesex	1-85937-158-2	£14.99	Tees Valley & Cleveland	1-85937-211-2	£14.99
New Forest	1-85937-128-0	£14.99	Thanet (pb)	1-85937-116-7	£9.99
Newark (pb)	1-85937-366-6	£9.99	Tiverton (pb)	1-85937-178-7	£9.99
Newport, Wales (pb)	1-85937-258-9	£9.99	Torbay	1-85937-063-2	£12.99
Newquay (pb)	1-85937-421-2	£9.99	Truro	1-85937-147-7	£12.99
Norfolk (pb)	1-85937-195-7	£9.99	Victorian and Edwardian Cornwall	1-85937-252-x	£14.99
Norfolk Living Memories	1-85937-217-1	£14.99	Victorian & Edwardian Devon	1-85937-253-8	£14.99
Northamptonshire	1-85937-150-7	£14.99	Victorian & Edwardian Kent	1-85937-149-3	£14.99
Northumberland Tyne & Wear (pb)	1-85937-281-3	£9.99	Vic & Ed Maritime Album	1-85937-144-2	£17.99
North Devon Coast	1-85937-146-9	£14.99	Victorian and Edwardian Sussex	1-85937-157-4	£14.99
North Devon Living Memories	1-85937-261-9	£14.99	Victorian & Edwardian Yorkshire	1-85937-154-x	£14.99
North London	1-85937-206-6	£14.99	Victorian Seaside	1-85937-159-0	£17.99
North Wales (pb)	1-85937-298-8	£9.99	Villages of Devon (pb)	1-85937-293-7	£9.99
North Yorkshire (pb)	1-85937-236-8	£9.99	Villages of Kent (pb)	1-85937-294-5	£9.99
Norwich (pb)	1-85937-194-9	£8.99	Villages of Sussex (pb)	1-85937-295-3	£9.99
Nottingham (pb)	1-85937-324-0	£9.99	Warwickshire (pb)	1-85937-203-1	£9.99
Nottinghamshire (pb)	1-85937-187-6	£9.99	Welsh Castles (pb)	1-85937-322-4	£9.99
Oxford (pb)	1-85937-411-5	£9.99	West Midlands (pb)	1-85937-289-9	£9.99
Oxfordshire (pb)	1-85937-430-1	£9.99	West Sussex	1-85937-148-5	£14.99
Peak District (pb)	1-85937-280-5	£9.99	West Yorkshire (pb)	1-85937-201-5	£9.99
Penzance	1-85937-069-1	£12.99	Weymouth (pb)	1-85937-209-0	£9.99
Peterborough (pb)	1-85937-219-8	£9.99	Wiltshire (pb)	1-85937-277-5	£9.99
Piers	1-85937-237-6	£17.99	Wiltshire Churches (pb)	1-85937-171-x	£9.99
Plymouth	1-85937-119-1	£12.99	Wiltshire Living Memories	1-85937-245-7	£14.99
Poole & Sandbanks (pb)	1-85937-251-1	£9.99	Winchester (pb)	1-85937-428-x	£9.99
Preston (pb)	1-85937-212-0	£9.99	Windmills & Watermills	1-85937-242-2	£17.99
Reading (pb)	1-85937-238-4	£9.99	Worcester (pb)	1-85937-165-5	£9.99
Romford (pb)	1-85937-319-4	£9.99	Worcestershire	1-85937-152-3	£14.99
Salisbury (pb)	1-85937-239-2	£9.99	York (pb)	1-85937-199-x	£9.99
Scarborough (pb)	1-85937-379-8	£9.99	Yorkshire (pb)	1-85937-186-8	£9.99
St Albans (pb)	1-85937-341-0	£9.99	Yorkshire Living Memories	1-85937-166-3	£14.99

See Frith books on the internet www.francisfrith.co.uk

FRITH PRODUCTS & SERVICES

Francis Frith would doubtless be pleased to know that the pioneering publishing venture he started in 1860 still continues today. A hundred and forty years later, The Francis Frith Collection continues in the same innovative tradition and is now one of the foremost publishers of vintage photographs in the world. Some of the current activities include:

Interior Decoration

Today Frith's photographs can be seen framed and as giant wall murals in thousands of pubs, restaurants, hotels, banks, retail stores and other public buildings throughout the country. In every case they enhance the unique local atmosphere of the places they depict and provide reminders of gentler days in an increasingly busy and frenetic world.

Product Promotions

Frith products are used by many major companies to promote the sales of their own products or to reinforce their own history and heritage. Frith promotions have been used by Hovis bread, Courage beers, Scots Porage Oats, Colman's mustard, Cadbury's foods, Mellow Birds coffee, Dunhill pipe tobacco, Guinness, and Bulmer's Cider.

Genealogy and Family History

As the interest in family history and roots grows world-wide, more and more people are turning to Frith's photographs of Great Britain for images of the towns, villages and streets where their ancestors lived; and, of course, photographs of the churches and chapels where their ancestors were christened, married and buried are an essential part of every genealogy tree and family album.

Frith Products

All Frith photographs are available Framed or just as Mounted Prints and Posters (size 23 x 16 inches). These may be ordered from the address below. From time to time other products - Address Books, Calendars, Table Mats, etc - are available.

The Internet

Already twenty thousand Frith photographs can be viewed and purchased on the internet through the Frith websites and a myriad of partner sites.

For more detailed information on Frith companies and products, look at these sites:

www.francisfrith.co.uk
www.francisfrith.com
(for North American visitors)

See the complete list of Frith Books at:

www.francisfrith.co.uk

This web site is regularly updated with the latest list of publications from the Frith Book Company. If you wish to buy books relating to another part of the country that your local bookshop does not stock, you may purchase on-line.

For further information, trade, or author enquiries please contact us at the address below:
The Francis Frith Collection, Frith's Barn, Teffont, Salisbury, Wiltshire, England SP3 5QP.
Tel: +44 (0)1722 716 376 Fax: +44 (0)1722 716 881 Email: sales@francisfrith.co.uk

See Frith books on the internet www.francisfrith.co.uk

To receive your FREE Mounted Print

Mounted Print
Overall size 14 x 11 inches

Cut out this Voucher and return it with your remittance for £1.95 to cover postage and handling, to UK addresses. For overseas addresses please include £4.00 post and handling. Choose any photograph included in this book. Your SEPIA print will be A4 in size, and mounted in a cream mount with burgundy rule line, overall size 14 x 11 inches.

Order additional Mounted Prints at HALF PRICE (only £7.49 each*)

If there are further pictures you would like to order, possibly as gifts for friends and family, purchase them at half price (no additional postage and handling required).

Have your Mounted Prints framed*

For an additional £14.95 per print you can have your chosen Mounted Print framed in an elegant polished wood and gilt moulding, overall size 16 x 13 inches (no additional postage and handling required).

*** IMPORTANT!**
These special prices are only available if ordered using the original voucher on this page (no copies permitted) and at the same time as your free Mounted Print, for delivery to the same address

Frith Collectors' Guild

From time to time we publish a magazine of news and stories about Frith photographs and further special offers of Frith products. If you would like 12 months FREE membership, please return this form.

Send completed forms to:
The Francis Frith Collection, Frith's Barn, Teffont, Salisbury, Wiltshire SP3 5QP

Voucher for **FREE** and Reduced Price Frith Prints

Picture no.	Page number	Qty	Mounted @ £7.49	Framed + £14.95	Total Cost
		1	**Free of charge***	£	£
			£7.49	£	£
			£7.49	£	£
			£7.49	£	£
			£7.49	£	£
			£7.49	£	£

Please allow 28 days for delivery	*** Post & handling**	**£1.95**
Book Title	**Total Order Cost**	**£**

Please do not photocopy this voucher. Only the original is valid, so please cut it out and return it to us.

I enclose a cheque / postal order for £ made payable to 'The Francis Frith Collection'
OR please debit my Mastercard / Visa / Switch / Amex card
(credit cards please on all overseas orders)

Number .

Issue No(Switch only)Valid from (Amex/Switch)

Expires Signature

Name Mr/Mrs/Ms .

Address .

. .

. Postcode

Daytime Tel No . Valid to 31/12/03

The Francis Frith Collectors' Guild

Please enrol me as a member for 12 months free of charge.

Name Mr/Mrs/Ms .

Address .

. .

. .

. Postcode

Would you like to find out more about Francis Frith?

We have recently recruited some entertaining speakers who are happy to visit local groups, clubs and societies to give an illustrated talk documenting Frith's travels and photographs. If you are a member of such a group and are interested in hosting a presentation, we would love to hear from you.

Our speakers bring with them a small selection of our local town and county books, together with sample prints. They are happy to take orders. A small proportion of the order value is donated to the group who have hosted the presentation. The talks are therefore an excellent way of fundraising for small groups and societies.

Can you help us with information about any of the Frith photographs in this book?

We are gradually compiling an historical record for each of the photographs in the Frith archive. It is always fascinating to find out the names of the people shown in the pictures, as well as insights into the shops, buildings and other features depicted.

If you recognize anyone in the photographs in this book, or if you have information not already included in the author's caption, do let us know. We would love to hear from you, and will try to publish it in future books or articles.

Our production team

Frith books are produced by a small dedicated team at offices in the converted Grade II listed 18th-century barn at Teffont near Salisbury, illustrated above. Most have worked with the Frith Collection for many years. All have in common one quality: they have a passion for the Frith Collection. The team is constantly expanding, but currently includes:

Jason Buck, John Buck, Douglas Burns, Heather Crisp, Lucy Elcock, Isobel Hall, Rob Hames, Hazel Heaton, Peter Horne, James Kinnear, Tina Leary, Hannah Marsh, Eliza Sackett, Terence Sackett, Sandra Sanger, Lewis Taylor, Shelley Tolcher, Helen Vimpany, Clive Wathen and Jenny Wathen.